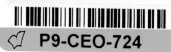

Schirmer's Visual Library
James Dean—Photographs

The creative phase of James Byron Dean's career was a tour de force lasting only eighteen months. Three films with the star directors Elia Kazan (*East of Eden*), Nicholas Ray (*Rebel Without a Cause*), and George Stevens (*Giant*) as well as friendships with the photographers Dennis Stock, Sanford Roth, and Roy Schatt created the myth of James Dean—at a breathtaking pace.

Only one and a half years separate his contract signing for *East of Eden* on March 6, 1954, and his fatal accident on September 30, 1955. These eighteen months sufficed to give permanent expression to the feelings of an entire generation of young people. Torn between the model roles of the dauntless Hemingway heros he admired and the poetic vulnerability of Saint-Exupéry's *Little Prince* he often quoted, the twenty-four- and twenty-five-year old Dean embodied the teenage rebel that emerged in the fifties.

This volume reproduces the most impressive still photos from the three films James Dean starred in as well as the most striking pictures of the three master photographers he often sat for. In his portrait of James Dean written in 1985, the writer and journalist Axel Arens (1939–1986) gave fitting tribute to the hero's vigorous life and his explosive end.

136 pages, 51 illustrations

James Dean

Photographs

With a text by
Axel Arens

Translated from the German by
Paul Kremmel

W.W. Norton
New York London

Photo Credits

Bettmann UPI/Bettmann Archive: S. 44/45, 81; dpa: S. 47, 126/127;
Sanford Roth, Focus: S. 2, 117, 121, 128/129; Keystone: S. 118/119;
Kobal Collection: S. 41, 50/51, 53, 54/55, 57, 60/61, 82, 83, 84, 85, 88/89, 90/91,
93, 95, 97, 102/103, 108/109, 111, 112/113, 115/116, 123, 124/125;
Motion Picture & TV Photo Archive: S. 37, 39, 42/43, 48/49, 57, 74/75, 98/99,
101, 105, 106/107; Roy Schatt: S. 77, 79; Dennis Stock – Magnum: S. 59, 62/63,
64/65, 67, 69, 70/71, 73, 86/87.

Cover photo:
Elizabeth Taylor and James Dean, still photo from *Giant*
Frontispiece:
James Dean with jointed doll (Photo by Sanford Roth)

Translation from German language by Paul Kremmel

Schirmer's Visual Library is an imprint
of Schirmer/Mosel Verlag GmbH, Munich
For trade information please contact:
Schirmer's Visual Library, 71 Great Russell Street, GB-London WC1B3BN
or Schirmer/Mosel Verlag, P.O. Box 40 17 23, D-8000 München 40
Fax: 00 49/89/33 86 95

A CIP catalogue record for this book
is available from the British Library

Reproductions: O.R.T. Kirchner & Graser GmbH, Berlin
Composition: The Sarabande Press, New York
Printed and bound in Germany

ISBN 0-393-30897-9

A Schirmer/Mosel Production
Published by W.W. Norton & Company
New York · London

Contents

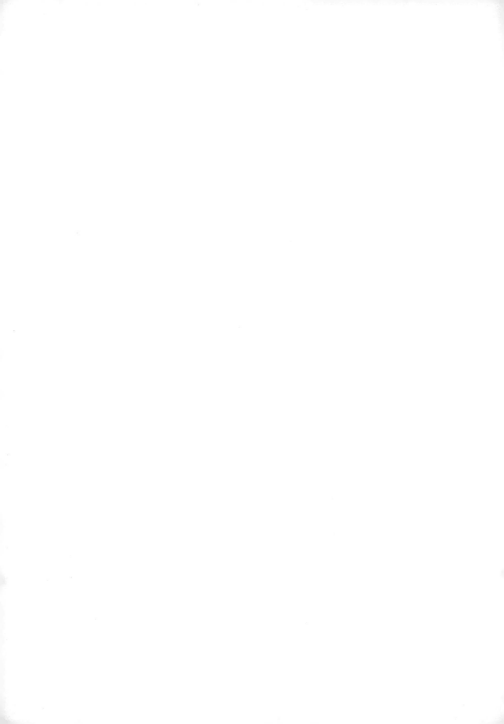

Axel Arens

James Dean

After the publication of Lord Byron's poem "Childe Harold's Pilgrimage," Byron wrote: "I woke one morning and found myself famous." As the twenty-year-old Mildred Dean, wife of the dental technician Winton Dean, read these words she was so impressed that she chose the name of the English poet for her first and only child's middle name. James Byron Dean was destined to become famous, which was exactly what his mother wanted. Mildred Dean had only read Byron's poetry; that Lord Byron was an eccentric bisexual with a weak constitution who died at twenty-six was unknown to her.

That James Byron Dean succeeded in becoming famous at twenty-four was not enough for the cunning-shy American teenage hero. He wanted more, he wanted to be an idol.

Death, immortal death, made him the hero of his dreams. He admired the racing driver Tazio Nuvolari, known as a devil on wheels, and Alberto Ascari, who was killed in his Ferrari in Monza; he fell in love with the Little Prince of the poet and pilot Saint-Exupéry, who crashed his airplane into the Mediterranean; he danced through the living room with his muleta, impersonating Manolete, the matador slaying the bull; Hemingway's *Death in the Afternoon* became his favorite book. The passage describing the death of the torero Manuel Granero he underlined with colored crayon: "He was twenty years old when he was killed by a Veragua bull that lifed him once, then tossed him against the wood of the front of the barrera and never left him until the horn had broken up the skull as you might break a flowerpot. He was a fine-looking boy who had studied the violin until he was fourteen, studied bullfighting until he was seventeen and fought bulls

until he was twenty. They really worshipped him in Valencia and he was killed before they even had time to turn on him."

After James Byron Dean had crashed into the right side of a massive Ford sedan at 90 mph in his sleek, silver-gray Porsche on Highway 466 on September 30, 1955, police officer Ernie Tripke wrote in his report: "The driver appeared to be dead. His head was uninjured but his chest was pierced by the steering column as if by the horns of a steer."

Patrolman Tripke had not read *Death in the Afternoon* and he was not prone to use symbolism. He was unaware of Lord Byron, Hemingway, and Granero, and even the name James Dean meant nothing to him. At the scene of the accident some thirty people stood around the silver wreck that lay in the grass like a crumpled cigarette package. They were all stunned; some were crying. Captain Tripke reported: "I had never heard of James Dean, the movie star. After much thought and pondering in my mind I felt it was the Jimmy Dean who sang cowboy and western songs . . . I kept getting radio calls asking about him. And when I got to the hospital later in the evening every phone in the place was ringing, and all the lights were flashing and we had news media calling from all over. That's when I heard for the first time that James Dean was a movie star."

His mother Mildred's wish was fulfilled: her Byron had become famous. And Jimmy's own prophecies came true: he had died the sudden death of a matador in the afternoon.

James Dean only lived twenty-four years, but the thirty years-plus he has been dead have made him immortal. A dead idol has no chance to impair his image. Humphrey Bogart remarked: "I think Dean died at the right time. He would never have been able to keep up with all that publicity." It was Jimmy Dean's fortuitous fate to have been killed in an accident in the prime of his life. He shared the same destiny as Manuel Granero, who is venerated not only in Valencia. To borrow from Hemingway, he would never again deliver a poor

fight—a lousy film; he would never even disappoint his aficionados—his fans.

The thirty people who stood around the scene of the accident were eyewitnesses of the actor James Dean's last hour and the birth of a myth—a legend named Jimmy.

On the side of the road were young people who, like Jimmy, were on their way to the motor races in Salinas in northern California. Among them was Lance Reventlow, son of Barbara Hutton and Woolworth heir. A half an hour before his death James Dean had talked shop with Lance Reventlow, who was also driving a German car, a Mercedes 300 SL. Several years later Lance Reventlow was killed in a private airplane crash in Colorado. Bill Hickman, an auto fanatic and friend of Dean who was driving a Ford van with trailer to bring the Porsche back to Los Angeles in case of a breakdown, stood dazed at the side of the narrow highway. With him in the van was Sanford H. Roth, a photographer who wanted to take pictures of the car-racing movie star for *Colliers* magazine. Through the front window of the Ford van he had taken the last photo of the living Jimmy Dean in the Porsche, the "Little Bastard," as Dean called it, in the sunlight on the way to Salinas. "See you in Paso Robles for dinner!" he had called out to Roth and Hickman. When they saw him again it was thirty miles to Paso Robles and the Porsche was a wreck in the grass near the road. Sanford Roth claimed to have taken pictures of the body, crushed behind the steering column. But out of respect for Jimmy and their friendship he never released the gruesome photos—a true story, perhaps. It is also possible that the photographer was so shocked that he couldn't press the shutter release. Sanford H. Roth died seven years later in 1962. The pictures have never been found.

Rolf Wütherich, a young mechanic from Stuttgart accompanying Jimmy to Salinas, was catapulted from the car on impact. He came to rest, seriously injured, on the grass near the wreckage. He never fully

recovered from the accident. After spending seven months in hospital with a fractured skull, he began to drink and was committed to an institution after attempting to kill his wife under the influence of alcohol. He died in 1981 in Kupferzell near Heilbronn when his car skidded out of control on wet pavement and struck a tree.

Between ambulance men, police, and mourning racing fans, a distraught and shocked student stumbled around. Holding a hand-kerchief to his bleeding nose, he stammered over and over: "I didn't see him. I just didn't see him." The people believed him, the police and later also the courts. Although he had failed to observe the right-of-way, the court conceded that he could not have recognized the forty-five-inch flat aluminum disc racing toward the intersection in the blistering central Californian sun. Donald Gene Turnupseed, the driver of the blue and white Ford sedan, was on his way home on a Friday afternoon to spend the weekend with his parents in Tulare.

Donald Gene Turnupseed, a twenty-three-year-old student at California Polytechnic College at San Luis Obispo, in his massive Ford sedan gave the death blow to a twenty-four-year-old Hollywood star and amateur car racer. Or, from another angle: with a short turn of the steering wheel he turned a Hollywood star, who had just completed three films, into an idol.

Turn-up-seed: Jimmy was the seed and Donald the man who turned it. He takes the credit for giving James Dean the status he now commands: uncontested immortality.

The fans Rudolph Valentino left behind cried for him, they mourned Jean Harlow, admired Humphrey Bogart, pitied Marilyn Monroe, and showed sympathy for Elvis Presley, but for Jimmy Dean they committed suicide. In the weeks following his death five girls in New York took their lives out of yearning for their beloved Jimmy. In Japan eleven teenagers killed themselves for a deceased actor they only knew from the screen. And as late as 1959, four years after his death,

two girls in Hamburg jumped, holding hands, from a fourteen-story building crying, "Jimmy, we're coming."

The hero cult, the idolization and idealization, the cult of the dead with fatal consequences raises the question: Who manages the leap from star to idol? And what are the prerequisites?

It is a proven advantage if the star comes from the same social stratum as most of the moviegoers, the potential fans. The life story of the star must be shrouded in and overshadowed by a transparent mystique. After the fact, the fans, the idolizers, must be able to say that they felt it coming, that their poor star had to end up the way he did. For despite his dollar wealth, he was poor because he was lonely. The requirement for becoming a cult hero is not primarily cinematic ability but charisma and fate, and fate is clearly defined as an unnatural death. It is also crucial for future immortality that this unnatural death take place at the pinnacle of fame.

To achieve immortality it is not sufficient to be a famous, celebrated movie star and to have a collection of Oscars on the mantelpiece. Even death itself is no guarantee for lasting fame. It all depends on when and how death occurs, and an early death is ideal for a cult image.

That this is so is shown by several "why-nots": why some movie stars, despite their great popularity, never became idols. Clark Gable because he didn't drown in the bathtub after shooting *Gone With the Wind*. Montgomery Clift because he wasn't shot by a gay stand-in after the final taps in *From Here to Eternity*. Frank Sinatra because he wasn't done in by Ava Gardner or the Mafia. (And because he systematically sung his way out of a role as possible cult figure.) Romy Schneider because she had the wrong relationships. If Mae West had been cast as a mother, her chances for immortality would have been greater, and Howard Hughes would have done better as a lover. Liz Taylor has failed because she continues to fill the gossip columns and empty the bottles instead of having become a missing person twenty-five years

ago. Paul Newman because he is still alive, still shooting films, making salad dressing and supporting charities. The same applies to Burt Lancaster, Robert Redford, Cary Grant, James Stewart, Sean Connery, Kirk Douglas, Clint Eastwood, and others. Richard Burton also didn't know when to stop.

What a heavenly career Ingrid Bergman would have had if the crazed Roberto Rosselini had driven them both over the edge of the crater at Stromboli to perish in the glowing lava. And Oscar Werner. He had what was needed to win the growing admiration of generations. But he too wasted his chance. He hung around his castle too long, indulging in Shakespeare and booze. Right after *Ship of Fools* or *Fahrenheit 451* at the latest, a bolt of fate should have struck him down. Or Marlon Brando. He was the predestined cult figure, the only one who could have surpassed James Dean in the immortal popularity scale. Now he is bald and rich and nothing more than a bald, rich, fantastic actor with a penchant for South-Sea women and many, many children.

James Dean is the candidate that scores a hundred points, the perfect idol. His death was the best timed, the perfect transition from star cult to glorification. He died at the pinnacle of his career. Donald Gene Turnupseed couldn't have crossed Highway 466 at a more propitious moment in all of cinematic history. In the California sunshine, James Dean died the death of a modern knight, the death in a racing car.

In comparison, the deaths of Rudolf Valentino (stomach poisoning), Jean Harlow (kidney failure), Humphrey Bogart (throat cancer), Marilyn Monroe (overdose of sleeping pills), and Elvis Presley (heart failure from obesity) were all rather sad, although Marilyn wins a few plus points (for the myth) because of the telephone receiver on her bed. Who knows, perhaps the President was on the other end as she drifted off in her Nembutal netherworld.

With the exception of Humphrey Bogart, all these stars were over

the hill in terms of their careers. Poor Marilyn, for example, was fired during the shooting of her last film, *Something's Got to Give*, for incompetence, irresponsibility, and drunkenness. Bogey, the man with the firm lips and soft heart, needed fifty-eight years and seventy-five films to become the cult king of the late-night movies. Jimmy became the eternal rebel with the sad eyes and sly grin at twenty-four after only three films.

Andy Warhol commented: "James Dean made just three pictures, but even if he had made only one he would still be the greatest male star of the '50s, and perhaps not just the '50s."

Of all the idols James Dean has the best legend. In contrast to the mixtures of biography and myth formation of cult figures such as Valentino, Harlow, Bogart, Monroe, and Presley, there is one fundamental difference: these stars all lived, loved, filmed, suffered, drank, enjoyed their popularity or suffered from it, they were eccentric, depressive, or lighthearted—and they (passively) became cult figures as the result of extenuating circumstances. James Byron Dean also lived through all these personal and professional phases, but he did more: he took an active role; he consciously set out, as far as it can be reconstructed, to build his own myth. Ever since he knew where he was going in life (which can be traced in detail in his biographies) he single-mindedly constructed his legend.

James Dean felt famous even when he was a nobody. He saw himself a star while cleaning tables in greasy fast-food joints. He wasn't the busboy but the star playing the role of busboy. And having become a celebrity after years of hard work, his ego was already a giant step further: he already sensed the cult beyond his death. Jimmy lived his own cult that his fans would make endless sacrifices for. In 1957 Robert Altman filmed *The James Dean Story*. And his fascination for the star remains, marked in 1982 by his filming of *Come Back to the Five and Dime, Jimmy Dean, Jimmy Dean*. For the past three decades, Dean fan Will O'Neil of Hawthorne drives the same stretch his idol drove on his

last day—from Los Angeles via Bakersfield to the junction of Highway 466 and 41. In the back of his station wagon is a silent gray passenger: an exact replica of the gravestone in Fairmount.

James Bryon Dean was born on February 8, 1931, in the small industrial town of Marion, Indiana, the first and only child of Mildred and Winton Dean. His father Winton, twenty-five years old at the birth of his son, worked as a dental technician at Marion Veterans' Hospital. America was in the midst of the Depression and the Deans had little money. His father tried to breed bullfrogs on his sister Hortense's farm to make more money. The idea was inept—during an economic crisis people are not going to spend their money on frogs' legs. The family then returned to Marion, where his father went back to work at Veterans' Hospital. In 1933, Winton Dean was offered a better position at Sawtelle Veterans' Administration Hospital in Los Angeles and the family moved to Santa Monica. Musically talented Mildred Dean built a puppet theater that occupied many of mother and son's waking hours. When Jimmy was four he was sent to dancing lessons and started to play the violin at five. The proud mother regularly sent pictures of Jimmy back to the relatives in Indiana. Grandmother Emma wrote back that Jimmy looked like a mixture of China doll and early apple, almost too cute for a boy. Shortly thereafter, Mildred died of breast cancer at twenty-nine, leaving nine-year-old Jimmy motherless. His father Winton was crushed and nearly bankrupt from the hospital bills, lacking even the funds to travel to Fairmount for the burial. So Jimmy made the long journey back to Indiana with his grandmother, on the same train as his mother's coffin.

Jimmy grew up on the farm of his Aunt Hortense and Uncle Marcus Winslow. Winton Dean's sister and his brother-in-law took loving care of the young boy, who had a hard time making friends with the other children. The Winslows encouraged him to develop the talents his mother had fostered. Jimmy was given drawing instruction by the

landscape painter Mary Carter. Aunt Hortense, whom he called "Mom," bought him a clarinet and when he asked for a drum he got that too. He was also supposed to take piano lessons, but that was too much effort for him. As Hortense Winslow observed: "The boy couldn't sit still. He was always moving about." Jimmy got the movement he needed in school sports. Photos show him as pole-vault jumper, basketball player, and member of the Fairmount High School baseball team. Although not without talent—a particularly good sprinter—his bursts of ambition were short-lived. He hated any task requiring diligence, endurance, and patience. Despite all his efforts, he failed to gain his peers' acceptance, remaining the loner, the newcomer. School friend Paul Weaver: "Jimmy was different than most boys. He was different in those days because, as I remember, he was often alone. Marcus and Hortense Winslow treated him like their own, but his name was still Dean."

Jimmy did receive recognition from Adeline Nall, who taught French and Spanish as well as speech and drama. From his freshman year at Fairmount, Jimmy took part in class plays, showing talent for theater and acting. And he didn't have to sit still. Aunt Hortense: "He was a very imaginative boy and always knew how to put himself into the act." And the school theater also gave him the recognition he sought. His career began with readings before the Fairmount Woman's Christian Temperance Union. As he told columnist Hedda Hopper in Hollywood in 1954: "I was just a little guy. But instead of reciting cute poems I read lengthy odes. That was quite odd, but I won all the prizes the WCTU had to give and later I won the Indiana state oratorical contest with a Dickens piece called 'The Madman.'" Adeline Nall praised her favorite pupil, not only for his stage appearances: "When it came to school theater he was really very bright. He did the stage lighting, made costumes, painted the flats, and helped me edit the scripts."

After school and rehearsals, Jimmy also helped out on the farm. He

milked the cows, fed the pigs, walked through the fields with his dog Tuck, and learned to drive a tractor. It was the beginning of his motor mania. Uncle Marcus: "Ever since he was ten we had trouble getting him off the tractor." The local pastor, the Reverend James DeWeerd, whom Jimmy looked up to, built the ten-year-old a "whizzer," a motorized bicycle, and Jimmy, being short-sighted, often fell over on it. He became a regular customer of Ruth MacDonald, the Fairmount optometrist. Four falls broke four pair of glasses—and several front teeth. Against Hortense and Marcus Winslow's better judgment, he got his first motorcycle at sixteen: a used 125 cm Jawa. The pastor had helped convince his foster parents. After a week he took his first spill, which didn't scare him; just one of many falls. The frequent spills on his motorcycle made him a good customer in Marvin Carter's motorcycle repair shop, where Marvin bent his machine back into shape. His involuntary dismounts led a motorcycle dealer to advise him to stay in first gear for his own safety. This kidding led to Jimmy's nickname amoung Fairmount motorcycle fans, who called him "One-speed Dean." To prove that the nickname was unfair he took even more chances on his bike. And he continued to be accident prone. Six years later, for example, after director Elia Kazan had contracted him in New York for *East of Eden*, the two were sitting in a drugstore. Kazan then accompanied the twenty-three-year-old to his bike to say good-bye. Jimmy wanted to make the four-thousand-mile trip to Holly-wood by motorcycle. But the trip ended before it began, with the motorcycle flat on the pavement and Jimmy's knee badly scraped. Elia Kazan ordered him to take the airplane.

After Dean's death near Paso Robles, Kazan admitted that he had always been worried about Jimmy's motorcycling: "Jesus, I never would have gotten on the back of it if I had known how bad his vision was."

Pastor DeWeerd was not only a car and motorcycle fanatic, he was also Fairmount's most fascinating personality. He had returned from

World War II highly decorated and with deep scars. He was said to be a friend of Winston Churchill's and to have been invited to his funeral by the Queen. The older Fairmount inhabitants describe him as a cross between missionary and actor. For the youthful James Dean he was a guru. Al Terhune, editor of the *Fairmount News*: "Jimmy stuck to DeWeerd like a parasite. He took on all his characteristics and lapped up everything the man said." Reverend DeWeerd played Jimmy classical music, taught him yoga, told him about poets and philosophers, and showed him movies of bullfights.

Jimmy was not an attentive student. John Potter, principal of Fairmount Junion High School: "He was a known troublemaker." And his teacher, India Nose: "Calling on him in class seemed to tear him out of deep thoughts." But the words Reverend DeWeerd taught him he carefully wrote down in a notebook. "Conformity is cowardice," the pastor said. And: "It is better to die in the remoteness of Mount Horeb and to have been honest with yourself than to die spoiled in the poisoned valley of platitudes."

In 1949, during his last year of high school in Fairmount, DeWeerd took Jimmy to the motor races in Indianapolis. DeWeerd had access to the pits and introduced Jimmy to the famous driver Cannonball Baker. Jimmy watched the race with wide eyes. On the way back to Fairmount, he asked the pastor about questions the race had churned up in him: the meaning of life, the threat to life by ever-present death, unexpected death, premature death.

DeWeerd told him to believe in personal immortality: "Death is merely a control of mind over matter."

In June 1949, after receiving his high school diploma, James Dean left Fairmount. It was not easy saying good-bye to "Mom" Hortense, Uncle Marcus, his drama teacher Adeline Nall, and James DeWeerd. Leaving his peer group in Fairmount was less difficult. His classmate Paul Weaver observed: "When I think back on Jimmy I only see him riding around on a motorcycle. And no girl ever rode behind him. He

somehow always felt uncomfortable around us. He told us he would soon leave little old Fairmount and wouldn't come back until he had become somebody."

His father Winton Dean, who had remarried in the meantime, got Jimmy to join him in California. Jimmy was apprehensive. His father insisted he study to become a lawyer, seeing no future for him in acting, but Jimmy persuaded him to let him enroll for prelaw as well as physical education and drama.

The first subject he dropped was P.E. His shortsightedness was a handicap, as well as his height (around 5'8"). In 1951, at the age of twenty, he decides to leave UCLA to devote all his efforts to acting. With Bill Bast, a drama student, he moves into an apartment in Santa Monica and the years of hunger, wild living, and uncertainty begin. James Dean works as a movie projectionist and part-time parking lot attendant. His first professional highlight is a two-minute Pepsi-Cola commercial. Bill Bast and James Dean join an acting study group. Dean plays the apostle John in the TV production "Hill Number One." Then a period of no work, no money. Sleeping during the day, he hangs around the bars on Santa Monica Boulevard (called "boys' town") at night. James Dean lives off Bill Bast, who also pays for the gas for Jimmy's '39 Chevrolet. Bast is an usher at CBS and has a friend called Beverly Wills, the daughter of the wealthy actress Joan Davis, who owns a luxurious house in Bel Air. Bill Bast is busy with his job at the CBS building, leaving James Dean time to devote to Beverly, whose mother's fridge is always full. The two-year friendship between Bast and Dean breaks up. Jimmy is on the street, sleeping in his car, since Beverly also wants nothing to do with him. During the day he visits the studios looking for a job and is finally hired as a part-time CBS parking lot attendant. He makes friends with his valet colleague and western-film actor Ted Avery. When Avery's wife goes off on a trip, Dean is able to stay in their apartment until she returns. To friends in Santa Monica he remarks: "I'm going to Hollywood. I want

to see my name in bright letters." But success is more modest than his ambitions. Dean plays bit parts in three movies. In *Sailor Beware* he makes a short appearance as a glum boxing trainer. In the other two films his lines are also limited. In *Fixed Bayonets*, for example, he only says: "It's a rear guard coming back."

In 1952 Jimmy leads a degrading life in Hollywood, a life in crass contrast to DeWeerd's "compromise is cowardice." When he has to pack his things at Ted Avery's he is taken in by radio producer Rogers Brackett. Brackett, who calls him Hamlet, takes him to the better, wealthier set in Hollywood, introduces him to the caviar and Cadillac society. But Jimmy remains alienated from the luxurious surroundings. He is a nobody amidst the throngs of name-droppers desperately hoping that the fame of the movie greats they constantly speak of will rub off on them.

James Dean lounges at the big-shot producers' swimming pools, he opens Champagne bottles for the rich has-beens of Beverly Hills, caddies for would-be directors in Bel Air—always seeking the dream role that never materializes or at best as a roll of dollar bills on the night table the next morning.

As Dean biographer Venable Herndon put it, he leads "the hard-boiled life of the expectant, the whores and cheats, the dog-eat-dog life of Hollywood. He is very much aware of swimming in the tow of those who give their best performances in bed and bars."

James Dean makes a hasty retreat from Hollywood

On the way to New York, he visits his Aunt and Uncle Winslow in Fairmount. Pastor DeWeerd lends him two hundred dollars.

Dean is fascinated by the big city. He lives in a small hotel room and goes to the movies three times a day. When the two hundred dollars are gone, he walks the streets of Manhattan, hunting for part-time jobs in snack bars, drugstores, or restaurants. For a few weeks he works as a codriver on a refrigerator truck. His free hours he spends in agents' waiting rooms. In six months he scrounges up six bit parts

which earn him a few dollars and a bad reputation among directors and production managers. Dean shows up for rehearsals unshaven, in dirty jeans, once even barefoot after a downpour. "Calculated sensations," as Dean biographer John Howlett has surmised? At the moment, his purposefully sloppy appearance brings no success. He can no longer pay for his hotel room and moves in with actress-dancer Elizabeth Sheridan, who earns the rent as usherette. When Liz loses her job, Dean moves into the attic flat of a TV director. His lodgings change but the misery remains.

Two good things come his way at this time: James Dean finds an agent, Jane Deacy, who tries her best to find work for him; and he passes the audition for Lee Strasberg's famous school for actors. He writes home to Fairmount: "I am very proud to announce that I am a member of the Actors Studio. It houses great people like Marlon Brando, Julie Harris, Montgomery Clift . . . If I can keep this up and nothing interferes with my progress, one of these days I might be able to contribute something to the world."

But the enthusiasm is short-lived. Director Elia Kazan: ". . . Dean was scarcely at the Studio at all. He came in a few times and slouched in a front row. He never participated in anything."

Bill Bast arrives from Hollywood, having given up hopes of becoming an actor and having taken a job in the PR department of CBS. Bast and Dean share an apartment with a young actress, both moving into her place. Dean works on a Hudson River tugboat. His friend Rogers Brackett introduces him to Broadway producer Lemuel Ayers. To land a part in Ayers' new play, *See the Jaguar*, Dean pretends to be an experienced sailor, having heard the Ayers is about to set off on a ten-day cruise. Dean is taken on as crew member and gets the part. The play is a flop in New York, but Dean's performance of Wally Walkins is highly praised. Critic Walter Kerr in the *New York Herald Tribune*: "James Dean adds an extraordinary performance in an almost impossible role: that of a bewildered lad who has been com-

pletely shut off from a vicious world by an over-zealous mother, and who is coming upon both the beauty and brutality of the mountain for the first time."

Success has arrived. For the first time James Dean has the chance to play James Dean: the player who sells playing himself as acting. Sammy Davis Jr. commented after Jimmy's death: "He did his number, and did it better than anyone in the world."

Spring 1953. The years of starvation are over. James Dean plays one part after the other. In thirteen months he appears in sixteen TV productions. His rent worries are over as he moves into a small apartment on West 68th Street.

With his new dollar freedom, he can freely express his personality, his moods, his feelings. When Dean is not in front of the studio cameras he can be the way he's always seen himself: Jimmy the misunderstood, Jimmy the star, Jimmy the doomed, Jimmy the rebel.

Jimmy begins to read. In the works of the deceased author Saint-Exupéry he finds the sentence: "Truth is invisible." He had known this all along: truth, his calling, lay within him, the others were simply too blind to see this at first glance.

He nails the horns of a bull to his apartment wall. As Bill Bast and his former roommate Liz Sheridan come to visit, he gives them the horns to wear, making them the bull and dancing around them with his muleta. When this game becomes too boring for him, he races out on the street waving his cape and dodging the passing taxis. When he's not the center of attention he can become furious. Photographer Roy Schatt recalls: "A group of us were eating in an Italian restaurant in the Village one evening, a couple of blocks away from the Circle in the Square Theater. A girl came in and plunked herself down on Marty Landau's lap. She hugged and kissed him, told him how wonderful he was, and how long she'd been after him . . . Then Jimmy jumped up

and leaned over the table, yelling, 'Stop it, don't do it with him. It's me you should be making love to. I'm the star.'"

Roy Schatt agrees to teach him photography. The course consists of Dean buying a Rolleiflex and allowing himself to be photographed with the camera in the most unusual poses by Roy Schatt, the professional. Depending on his whims, he also takes a few photos of his teacher, his actor friends, and bar acquaintances. Patience in the painstaking search for the optimal shot or for darkroom work is not his forte.

James Dean also spends some of his time with books. In addition to *The Little Prince* he is fascinated by the tome *The Seven Pillars of Wisdom* by the Arabia hero T. E. Lawrence, who died in 1935 in a motorcycle accident. He copies verses out of a book that the Spanish poet García Lorca, shot and killed in 1936, dedicated to the bullfighter Ignacio Sanchez Mejias, who died in the arena.

When his friend the composer Leonard Rosenman accuses him of not really reading his books but just fishing out quotations for his morbid death wishes, Dean throws him out of the apartment, slamming the door behind him and refusing to speak to anyone. These are the days and nights he feels particularly close to the Little Prince, who tells him, "It will look as if I am dead but this will not be true . . ." This is the Dean who both enjoys and is tormented by his anticipated death, and the Dean who writes Pastor DeWeerd: "I think there's only one form of greatness for a man. If a man can bridge the gap between life and death, I mean if he can live on after he dies, then maybe he was a great man. The only success or greatness for me is immortality."

This is the Dean about whom George Stevens, the director of his last film remarked: "He was a disturbed boy, tremendously dedicated to some intangible beacon of his own—and neither he nor anyone else might ever know what it was." Julie Harris, his costar in East of Eden:

"He was like a small boy, very lonely. He was really a beautiful boy. And he really knew how to draw."

The hours spent in the company of his dead heroes are the hours in which he draws the picture of his own immortality. And then come the hours in which he paints his own self-portrayal with wild, bold colors, when he can't stand not being the center of all worldly attention.

Roy Schatt: "One evening after a photo session at my place, the usual crew . . . and I sat around over sandwiches and drinks. It was a while before we noticed that Jim had left us. 'Hey, Jimmy,' we yelled. No response . . . The next thing we knew there was a hell of a racket out in the street, complete with horns blowing and people yelling. We ran to the window and opened the venetian blind. There, in the middle of the street, sitting cross-legged in my chair, smoking a cigarette, was our boy, holding up traffic. As we all flew out the front door, we looked beyond the chair and saw a long string of headlights and people getting out of cars. Marty and I grabbed Dean from the chair—and also from a tall, angry-looking guy with big hands who looked ready to pummel him. Jim acted like a rag doll when we pulled him from the chair, his arms and head flopping around, the rest of him just dead weight. Bob and Billy picked up the chair. Once inside, we all looked at the grinning Dean. 'God damn it, Jim,' I yelled . . . After I calmed down, I asked him, 'Why, Jim, why?' He took a fresh cigarette and sat in the chair that had been put back in its place. He lighted up and looked at all of us. 'Don't you sons of bitches ever get bored? I just wanted to spark things, man, that's all.' He got up and began bongoing the side table. 'Look at you. Before I did it, we were all sitting quietly eating and drinking, and outside a lot of nine-to-fivers were going home to their wives, like they do every night. Now you're all juiced up, and so are they, man. They'll talk about it for years.'"

With his success, Dean can afford to be arrogant and excessive. For his second role in a Broadway play, the thieving, blackmailing Arab youth in *The Immoralist*, based on the André Gide novel, he receives a Daniel Blum Theatre World Award as one of the year's most promising young actors. Enticing, lucrative offers from Hollywood follow.

Jane Deacy, his loyal agent and the third "Mom" in his life, lands him a contract with Warner Brothers. Twenty thousand dollars for his signature for a leading role in the filming of John Steinbeck's *East of Eden*.

Getting off the plane in Los Angeles, James Dean, pallid from the rainy New York winter, carries his clothes in a few paper bags and several books under his arms, "dressed like a tramp" (columnist Hedda Hopper). Bill Bast picks him up at the airport and they drive to Dick Clayton's, the agent Jane Deacy assigned to look after him in Hollywood. Bill Bast recounts: "Jimmy walked into the office and—without introducing himself or saying hello—sat on the desk, turned his back to Clayton and started to make a long-distance call. After we were outside again I told him, 'What are you doing? Are you carzy?' 'Ah,' he said, 'they love that, they really lap that up.'"

Jimmy Dean is right on target. Scruffy misfits are in. Marlon Brando had become a star in *Streetcar Named Desire* and will receive an Oscar for his role as Terry Malloy in *On the Waterfront*. Montgomery Clift had achieved stardom in *A Place in the Sun* and was only refused an Oscar for his role as Prewitt in *From Here to Eternity* because of his alcoholism.

James Dean is uncomfortable in Hollywood. The adjectives that describe his experience range from brokenhearted to destitute. Before shooting begins, he finds comfort in the toys his advance enable him to buy. To his New York girlfriend Barbara Glenn, he writes: "Honey!!! I'm still a California virgin. Not really surprising. I'm holding myself back—Dean the atomic bomb. A new addition has been added to the Dean family. I got a red '53 MG. My sex pours itself into fat curves,

broadslides and broodings, drags, etc. You have plenty of competition. My motorcycle, my MG and my girl. I have been sleeping with my MG. We make it together, honey."

Elia Kazan, who witnessed the motorcycle spill in New York, has no interest in losing his leading actor during the shooting: the studio prohibits him from driving while shooting is in progress.

Jimmy to Barbara Glenn: "I haven't written because I've fallen in love. It had to happen sooner or later. It's not a very good picture of him but that's Cisco the Kid (a palomino), the new member of the family. He gives me confidence. He makes my hands strong. May use him in the movie. I'm very lonely. Your card smelled so good. I hate this place."

At the beginning of August Jimmy can leave Hollywood. The outdoor shooting of *East of Eden* takes place in northern California, in Salinas. Six weeks later, when the crew returns to the Warner studios in Burbank for indoor shooting, Elia Kazan arranges for James Dean to live in a studio building. He himself moves into the dressing room next door to keep an eye on his unpredictable actor—or at least to try.

Elia Kazan, who saw Jimmy on Broadway and was so excited at his brash style, his underacting, that he signed him on for the role of Cal in *East of Eden* (competing for the role were Marlon Brando, Montgomery Clift, and Paul Newman), takes a paternal, protective interest in his new star. After the day's shooting he sits with him in the bare room, talks with him, drinks with him, sometimes until dawn. The director becomes his friend but also a critical observer: "Jimmy was more sensitive than anyone I had ever met. He was frightfully narcissistic. After the MG and the palomino, he bought expensive camera equipment and I remember how he stood in front of a mirror and photographed himself. He held the camera under his chin and took one picture after the next. He paid particular attention to the kind of image he was creating."

However difficult it was for his colleagues to put up with him

(George Stevens, director of his last film: "It was a hell of a headache to work with him"), he comes over extremely well on the screen. From the outset the film audience feels the sadness in his face and eyes that ask: "Why have you all deserted me?" And also his mocking smile that says: "I'm gonna show you!"

The premier of *East of Eden* is on March 9, 1955, in New York, with Marilyn Monroe, Marlene Dietrich, and Eva Marie Saint serving as usherettes. The movie is a smash hit from the start.

James Dean is absent from the premiere. While the New York critics praise the actor Dean, Jimmy in Hollywood works on his image. In jeans and T-shirt he roars up and down Sunset Boulevard on his new Triumph 500, dropping in at Googie's, his favorite haunt, and with a Chesterfield hanging out the corner of his mouth tells a fawning Dean reporter: "I can't get up in front of people and bow. I can't handle that scene."

The small boy who plays with dolls but would rather be roughing it up with the boys, the college student making costumes for the theater festival who would rather be standing on the winners' platform at an athletic contest, the pale actor who has to wipe up catsup from other people's tables dreaming all along of standing in a sunny arena as a celebrated matador with a bloody muleta, this oversensitive dreamer takes refuge in the role of the bad boy, the wild man, the rebel. And his ersatz father DeWeerd provides him with the elevated platform on which he can perform his eccentric, excessive caprioles. Success is his reward. The pungent sparkler James Dean ignites. Dean becomes the best-paid misfit in Hollywood. He can even afford to abuse the man who pays him, Jack Warner, the tycoon and Hollywood mogul. Jack Warner needs the man who fills his coffers. James Dean is the future god of American teenagers. But there are still other gods before him who began their rule over the hearts and pocketbooks of the youth somewhat earlier: Marlon Brando and Montgomery Clift. Jimmy is driven by the need to feel his success. Night after night he rides his

motorcycle down Hollywood Boulevard, over to Westwood and back out to downtown Los Angeles. He revels in the sight he had longed for so much: the picture of lines of people in front of the movie theaters to see him, the sight of JAMES DEAN in large letters shining over the heads of the people. But the picture quickly fades, satisfying his vanity only momentarily. At night he sits wide awake on the edge of his bed, and the tumor of grand illusions leaves him no peace. He is the greatest! Who is Marlon Brando? He plays Elvis Presley's hit "You Ain't Nothin' but a Hound Dog" to Brando's answering service. Brando ignores the insult. Later Brando commented to Truman Capote: "When I finally met Dean, it was at a party, where he was throwing himself around, acting the madman. So I spoke to him. I took him aside and asked him didn't he know he was sick? That he needed help." In New York he had also terrorized Montgomery Clift, shouting into his phone, "I'm a great actor and you're my idol and I need to see you because I need to talk to you and I need to communicate." Montgomery Clift refused to acknowledge this nuisance. He changed his telephone number.

Dean's biographer John Howlett wrote: "James Dean never had detachment, objectivity or caution . . . His lack of pretence . . . presupposed a refusal to compromise, an arrogance, that he applied with near disastrous effects in his day-to-day life."

In March 1955, shooting begins for *Rebel Without a Cause*. Here Jimmy can play James Dean, true to life. The vulnerable rebel at odds with his parents, the young boy struggling for peer recognition. James Dean plays his own image. The boundaries between the Dean movie and the private Dean blend together like wet paint. With the one difference that Jimmy—Jim in the film—drives around in a Porsche Speedster in his free time and in a '49 Mercury in the film. This autobiographical discrepancy is not an oversight—an all-American boy anno 1955 drives an American car. In the movie Jim wins the chicken run in his car. The real Jimmy is also successful on Sunday afternoons at the race track. With his white convertible speedster he

takes part in six small racing events. He is a starter in Pacific Palisades, Pasadena, Palm Springs, and Bakersfield. And the photographers are always with him. Jimmy, the racing driver. Jimmy next to the car, Jimmy with the trophy. He talks about giving up movies and entering the formula-one races in Europe. His success in the California Sports Car Club races, open to anyone who pays the seven-dollar entry fee and pastes a start number on the door, make him feel as if he were called to follow in the footsteps of his dead idols Nuvolari and Alberto Ascari. Ken Miles, an experienced driver in his sixties who raced against Dean in 1955, said that although the actor took insane risks with his own life, he never took risks when another driver was involved: "The odds were against his becoming a great racer."

Jimmy, lacking all sense of proportion, doesn't agree. He sees the trophies and he sees himself with the trophies in newspaper and fan magazine photographs. As Natalie Wood, his costar in *Rebel*, commented: "He was fascinated by the stories that were written on him. He did all he could to find out how other people saw him and what they thought about him."

Jimmy the racing driver, Jimmy the hermit, Jimmy the bullfighter, Jimmy the Little Prince, Jimmy the rebel, but above all else: Jimmy the author of his own screenplay.

"Change is the nature of genius," he writes, the Reverend DeWeerd. Jimmy makes his own laws. His antisocial behavior has become part of his style. And the scruffy character with the smart-aleck grin and a Chesterfield in the corner of his mouth sells himself very well. Only once does this tactic let him down. In retrospect, the chapter on unrequited love fits the legend perfectly like salt in the soup, lights on the Christmas tree, lily pads in the pond. Jimmy falls in love, as the saga would have it, with the beautiful, dark-haired, twenty-one-year-old girl Pier Angeli.

Jimmy, the changeable, has unlimited freedom. Usually seeking

more the company of men (David Bowie: "I was by no means the first bi-sexual . . . James Dean did it very subtly and very well. I have a good feeling for that, and Elizabeth Taylor confirmed my suspicion."), he now walks hand in hand with "Miss Pizza," and hand-in-hand they stroke his palomino Cisco and only have eyes for each other—and the photographers. Evening after evening, the young couple sit in the Italian restaurant Villa Capri, drinking Tuborg beer and eating pizza, and making plans for their future: the children they want to have, their wedding, their honeymoon, the private papal audience. And Jimmy will buy himself a comb and everything will be wonderful. But what good are all rose-colored plans when the nasty mother-in-law-to-be is dead set against it? Pier's mother refuses to let the scruffy actor into her house, much less into her family. Basta.

Back in New York to work on a TV production, James Dean calls Pier in California. He hangs up speechless and starts to cry. No one actually saw him, but his friends maintain that he cried.

The fact of the matter is that Pier Angeli is engaged to marry the Italian-American crooner Vic Damone. Thirty-two choir boys sing at the wedding, Wagner and Mendelssohn's Wedding March are played. A large crowd gathers in front of the church. A man from the *Hollywood Reporter* claims to have seen James Dean roaring off on his motorcycle as the bride and groom leave the church, but no photographer captured the scene.

In the coming weeks there are ample opportunities for photographs. *Life* magazine commissions photographer Dennis Stock to do a major photographic essay on the new star. Jimmy travels with him to New York and to Fairmount. No star can escape having cameras around all the time. But James Dean uses this return to places in his past to consciously shape his legend. The journey becomes an unparalleled ego trip. Jimmy Dean—in pure form, spontaneous and unrehearsed. Didn't he say he would return to Fairmount when he had made it in

life? Well, now he's here, sitting in the gym at the Sweethearts Ball giving out autographs. And his former classmates admiringly stand around, flashing pictures of him with their small cameras.

Dennis Stock is a Magnum photographer, one of the greats of his profession, but it is Dean who chooses the settings and camera angles. The successful racing driver takes the man with the camera to Marvin Carter's motorcycle repair shop. Dean has the feel for publicity-inspiring symbolism. He leads the *Life* man to the cemetery and poses alongside the CAL DEAN tombstone, an allusion to his own person: he was Cal in East of Eden and soon there would be a Dean tombstone for him too. There are even pictures of his funeral before his death. He drags Dennis Stock into Vernon Hunt's Funeral Home, climbs into a coffin and gives a victory sign in this ultimate position. In the next shot, a few centimeters further on the film roll, he already seems to have left Mr. Hunt's establishment, his arms crossed and eyes closed. In his dreams he's already on his way to join Alberto Ascari, Manuel Granero, Manolete, T. E. Lawrence, Saint-Exupéry, and the Little Prince.

He once told Roy Schatt, "I'm not going to live past thirty." In *Rebel*, Jimmy's Jim says, "I never figured I'd live to see eighteen." James Dean was twenty-four when he posed in the Fairmount coffin—and very close to fulfilling his own prophecy.

In June 1955, joins the shooting of *Giant* in the middle of nowhere, in the small, sweltering town of Marfa, Texas. *Giant* is a big-budget production costarring Elizabeth Taylor and Rock Hudson. James Dean plays the rebel, the angry young man who suddenly strikes it rich and challenges the rich landowners. There is friction during the shooting. Director George Stevens insists that Dean give a perfect portrayal of ranch hand Jett Rink and has no sympathy whatever for Dean's egocentric off-camera performances. Dean also has his trouble with the other actors. Rock Hudson: "He never stepped into camera range without first jumping into the air with his feet up under his chin or

running at full speed around the set shrieking like a bird of prey. Dean was pretty hard to take."

Dean is a fiend for rehearsals. Sometimes up to thirty takes are needed before he's satisfied. He even alienates the production crew. After one exchange, Dean sighed, "Maybe I'd better go to the moon," whereupon a lighting assistant replied, "We'll help you pack." When the shooting for *Giant* is finally completed all involved in the mammoth project are relieved and Dean feels a sense of liberation. He wants nothing more to do with filmmaking for some time.

But mid-September, "Mom" Deacy arrives from New York and persuades him to sign new contracts. NBC offers him $25,000 for a TV drama, the highest sum that had ever been paid for a television production. Warner Brothers offers Dean $900,000 for six films. The next script is already waiting: the lead role in *Somebody Up There Likes Me*. Dean signs the contracts but insists on a one-year break from the cameras. He wants to live it up, to get his fill of racing.

For $6,900 he buys a Porsche Spyder, a competition model produced in a limited series of one hundred. In 1985, thirty years later, the last surviving model of this type is sold for $120,000. For five days James Dean enjoys his expensive purchase. For five days he drives around Los Angeles in his sleek racer, showing it off to all his friends. He signs up for the sports car race in Salinas and applies the racing number 130 to the front and sides. On the back, in black letters, he paints the car's nickname: "Little Bastard." On September 30 at about 2:30 p.m. he sets out with his mechanic Rolf Wütherich from Hollywood. Outside Bakersfield they are stopped by a patrolman, who gives him a ticket for speeding. Dean curses. Several weeks earlier he had done a TV spot for a National Highway Committee road safety campaign, warning young people not to speed. "The road is no place to race your car. It's real murder. Remember," James Dean said winking, "the life you save may be mine."

Patrolman Otie V. Hunter admires the sports car and has a look

under the hood. Dean tells him he's on his way to take part in the races at Salinas. Back in his car the patrolman warns him: "If you don't take it slower, you'll never reach Salinas alive."

He never did reach Salinas alive. Shortly before Cholame, at the junction of Highway 466 and 41, Donald Gene Turnupseed turns left in front of him. "He's gotta stop," Dean shouts before the impact, "He's gotta see us." Moments later Turnupseed tells the onlookers, "I never saw him."

"Death is the one inevitable, undeniable truth," James Dean said. His fans couldn't accept the truth. Even one year after his death, Warner Brothers received up to 7,000 letters a week to be forwarded to Jimmy. His fans suspected him everywhere: in a Russian monastery, in a clinic for plastic surgery, but not in heaven or hell.

Across America expectant mothers emerge, claiming to be bearing Jimmy's child. In a single day four girls call Bill Bast in New York with this story. But the Dean cult does not just produce strange fantasies. Millions of dollars have been earned to this day on the T-shirt, poster, souvenir, clothing business with the dead hero. Equally lucrative and bizarre was the business from "Little Bastard," the smashed-up car. For three months it was exhibited as a warning against reckless driving at various high school playgrounds in Los Angeles. Then it was bought for a thousand dollars by Dr. William Eschrich, a Porsche fan, who removed the undamaged engine and gearbox. The empty aluminum hulk he sold to a couple who displayed it at a Los Angeles bowling alley. Viewing alone cost twenty-five cents, and fifty-cents to sit in the death seat and touch the broken, blood-stained steering wheel.

Eight thousand tickets were sold before they were forced by a citizens' group and a court injunction to end the exhibition. Then the car was cut up into a thousand pieces and sold to Dean fans. Over the next twenty-five years, twenty-six brake pedals, twenty steering

wheels, thirty window cranks, and innumerable rearview mirrors emerge. Stephen Alkire, a Dean and Porsche fan from Porteville, estimated that all the original James Dean Porsche parts would suffice to build seventeen complete cars.

The seed Jimmy sowed began to sprout, the myth grew and grew, taking on grotesque, perverse, even fatal forms.

Why didn't Elvis and Marilyn fans spring, hand in hand, from the roofs? Because Elvis and Marilyn were only stars who had been elevated to idols. Jimmy was more. Although he earned his money as an actor, he was more than just a paid performer; he had a motive, a message that he sought to articulate.

What he conveyed on and off camera to his receptive public was the rebellious adolescent, as witnessed in the title *Rebel Without a Cause*, his best and most autobiographical film. Though the title itself is misleading; a purposeful misinterpretation. The Warner movie moguls wanted to earn money on the film about the teenage rebel but also to distance themselves from this delicate adolescent subject by giving a distorted message: Look at them, these alienated teenagers! They rampage, rebel, vandalize—and they don't even know why!

To be sure, the occupational label "rebel" is too weighty and dramatic for an unruly twenty-four-year-old motorcycle, sports car, and beer freak. John Brown was a rebel, and Che Guevara. But to claim that Jimmy Dean and millions of dissatisfied adolescents who became his fans and followers didn't know what they were doing is false. They knew very well. Their rebellion was aimed at the self-satisfied, established world of their parents, teachers, and schools. 1955 was the year of the best America ever. America without war— the episode in Korea had just ended at the cost of $23 billion and 54,000 deaths. Prosperity, growth and tranquillity, the prime civic goals, dominated the country. The Coca-Cola culture blossomed. The obvious marks of this culture were the automobiles, the gas guzzlers.

Never before were cars so luxurious and ostentatious than in these years. A '55 Cadillac Eldorado was the literal and visible symbol of a self-content America.

America was intact, cleaning, polishing, and grooming itself. Communists, dissidents, and critical minorities were neatly disposed of. That was Mr. McCarthy's job, with Dwight D. Eisenhower and Mamie grinning all the while. They had a firm hold on America. But not quite on its youth. The young were becoming restless.

James Dean expressed what many felt. As his face emerged on the screen in 1955 and the tabloids related how wonderfully rebellious he was, he immediately came to personify a major portion of America's youth.

Jimmy gave expression to the discontent, the unhappy, the suppressed (by parents, school, and police), the latchkey kids, the spiritually starved. Jimmy up on the screen and hundreds of like-minded in the darkness, sprawled in their seats chewing gum and eating popcorn. The identification worked for both boys and girls. For the girls he was an ideal figure of the courageous yet sensitive friend. And the boys felt the way John Dos Passos had described: ". . . they still lined up: / . . . before the mirrors in the restroom/to look at themselves/and see/James Dean . . ."

Truly amazing. And the rebel is still robust. Today, three decades after his death, the showings of *Giant* are sold out when it runs at Lämmle Continental, an old movie palace in Los Angeles. And when the name James Dean appears in the opening credits, the people go wild. To the names of Elizabeth Taylor and Rock Hudson, there is no reaction whatever. And when the hired hand gives the one-two punch with his oily fists to the stinking-rich landowner Benedict (Rock Hudson), sending him flying onto the finely laid-out table, three hundred people clap and stomp and shout for minutes on end: "Jimmiiiii." He did the right thing for all of them.

Dean's actor colleague Dennis Hopper remarked, "I think he was

pure gold." The author Maurice Zolotov commented: "He was surly, ill-tempered, brutal." Both half-truths. He was a golden brute who still shines today. The one-eyed Sammy Davis Jr. saw it all very clearly: "He did his number, and did it better than anyone in the world." And you outwitted them all with this number that you worked on so feverishly to the last second. That fateful 30th of September has come round again, Jimmy Dean, you little bastard: "Cheers!"

Filmed between May and August 1954 by director Elia Kazan, based
on the last third of the John Steinbeck novel

*In this modern rendering of the Cain and Able story, James Dean plays the
role of Cal Trask, the unloved and hence rebellious son of a California lettuce
farmer who is jealous of his brother Aron, his father's favorite child.*

*To compensate for the losses from his father's refrigerated lettuce venture,
Cal secretly speculates with bean crops. The investment pays off when war
break out and Cal gives his father the money as a birthday surprise. His
father rejects the gift, which he feels was ill-gotten gain, and tells Cal to be
a "good" son like his brother Aron.*

*Enraged at his father's rejection, Cal tells Aron the secret of their
supposedly dead mother; as Cal discovered, she runs the local whorehouse in
nearby Monterey. Aron, who idolized his mother, is shocked and, spurning
his pacifism, goes off to war. His father suffers a stroke and Cal looks after
him, a small trace of reconciliation at the end of the film.*

Cal roaming the streets of Monterey in pursuit of the woman he believes to
be his allegedly deceased mother. His suspicions are confirmed and he
discovers that she runs the local brothel. Film still from *East of Eden*, 1954.

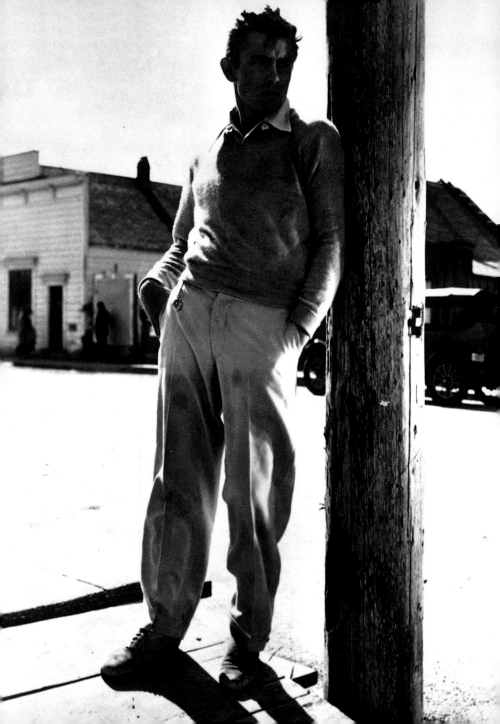

A dangerous maneuver: Cal hops freight trains to get from Salinas to Monterey. A still from *East of Eden*.

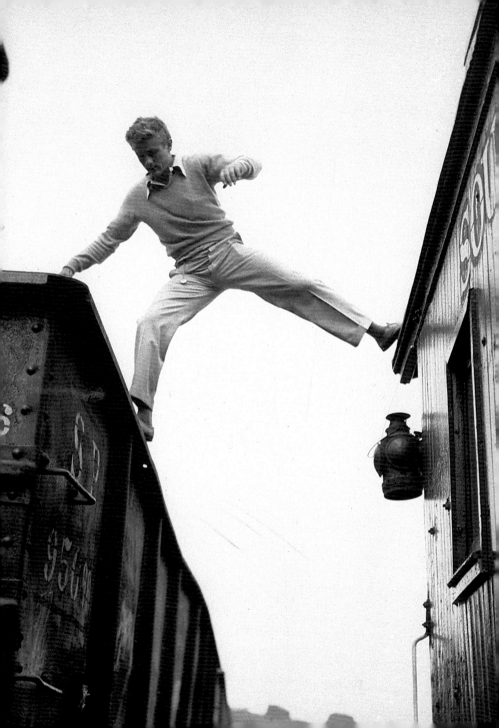

Page 41

A still from *East of Eden.*

Pages 42/43

Portrait of the brothers: Cal playing his recorder while his brother Aron (Richard Davalos) looks on from the bed—a picture with hauntingly melancholic undertones. Film still from *East of Eden.*

Pages 44/45
Film still from *East of Eden.*

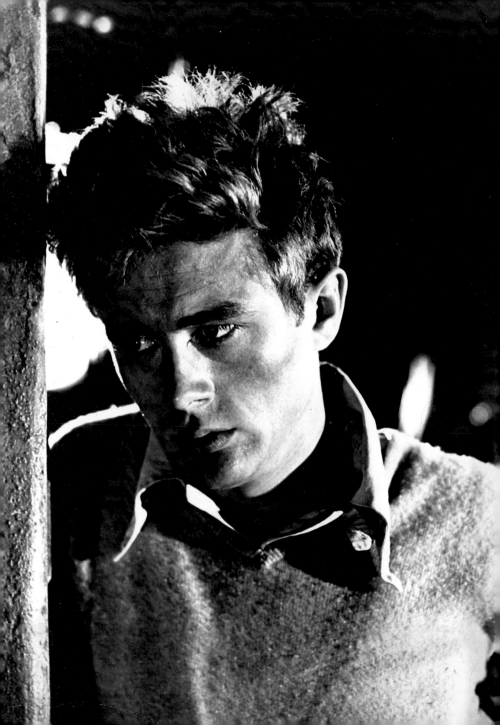

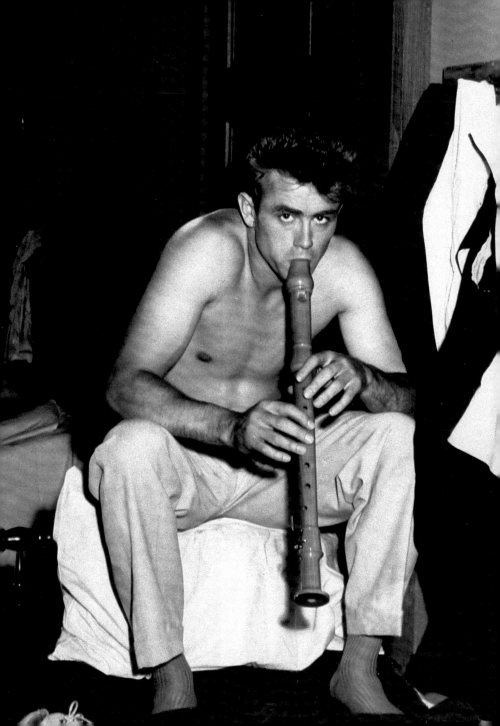

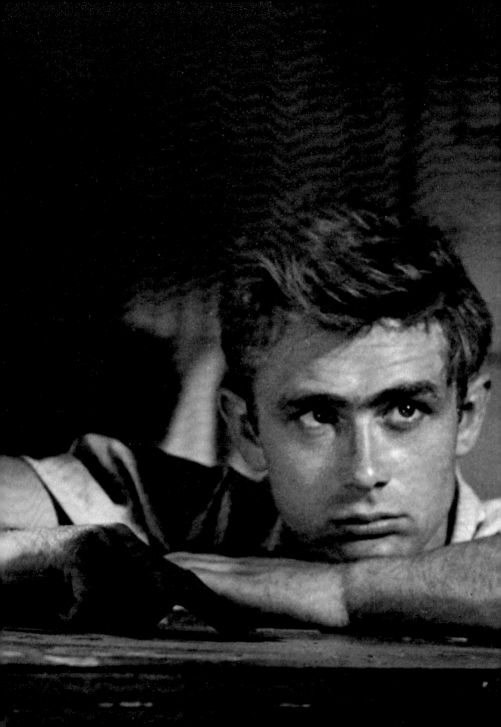

Page 47

Cal in his beanfield. A still from *East of Eden.*

Pages 48/49

Cal asking his mother (Jo Van Fleet) for a loan to finance his bean field project. Film still from *East of Eden.*

Pages 50/51

Cal's confrontation with his father Adam (Raymond Massey). A still from *East of Eden.*

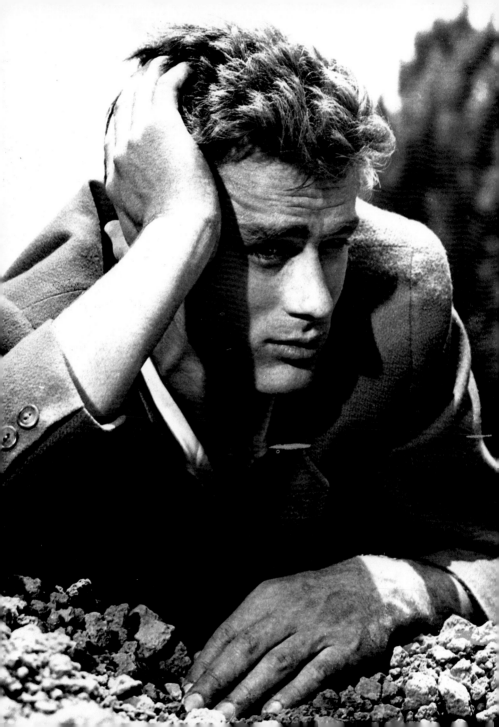

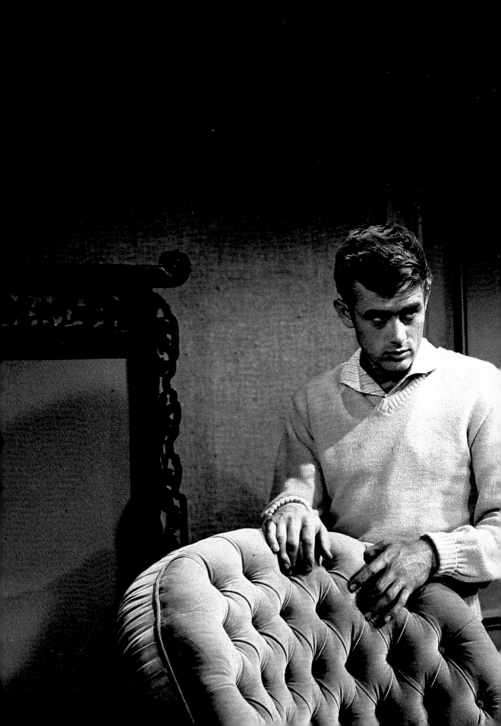

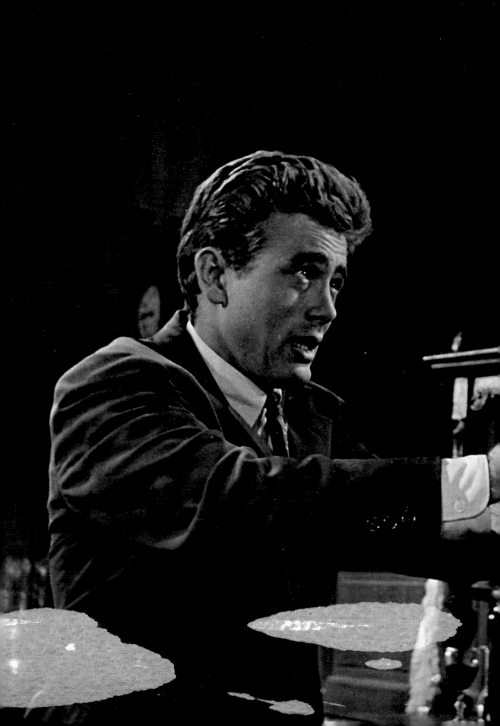

Page 53

Film still from *East of Eden*.

Pages 54/55

Cal with Abra (Julie Harris), Aron's financée, who tries to reconcile Cal
with his father. A still from *East of Eden*.

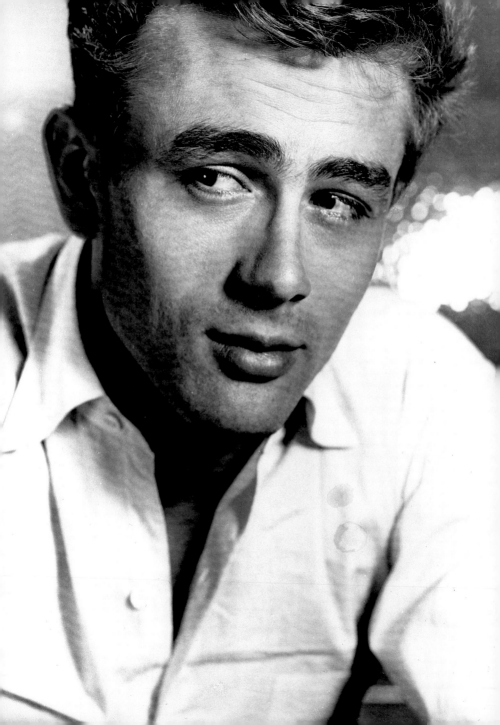

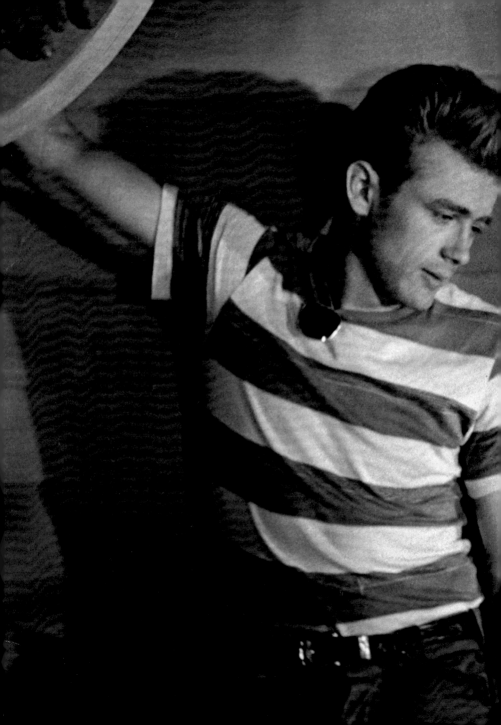

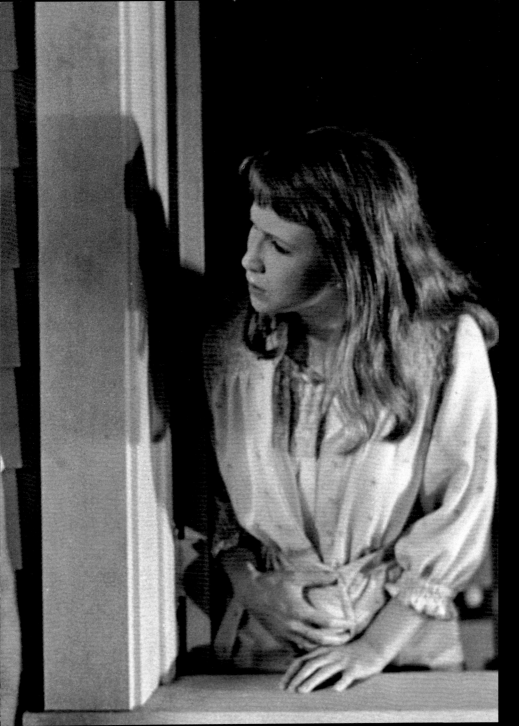

A happy ending is suggested by Abra's affection for Cal after Aron has left
the family. Film still from *East of Eden*.

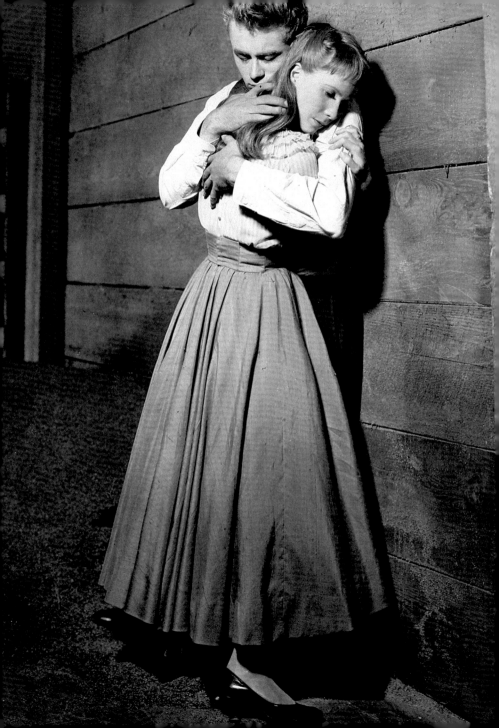

Fairmont, Indiana

In February 1955, after completion of shooting for East of Eden *but before the premier, James Dean travels to his hometown Fairmount with the twenty-seven-year-old photographer Dennis Stock, who is commissioned by* Life *magazine to do a photographic essay on Dean. It appears on March 7, 1955, entitled "Moody New Star," two days before* East of Eden *is released.*

Page 59

James Dean on the streets of Fairmount.

Pages 60/61

James Dean at the entrance to the Winslow farm where he grew up with his Aunt Hortense and Uncle Winslow.

Pages 62/63

James Dean with his cousin Markie at the Fairmount Cemetery before the tombstone of a family relation who, curiously, has the same name—Cal—as James Dean in his first major film, *East of Eden*.

Pages 64/65

Group portrait with calves.

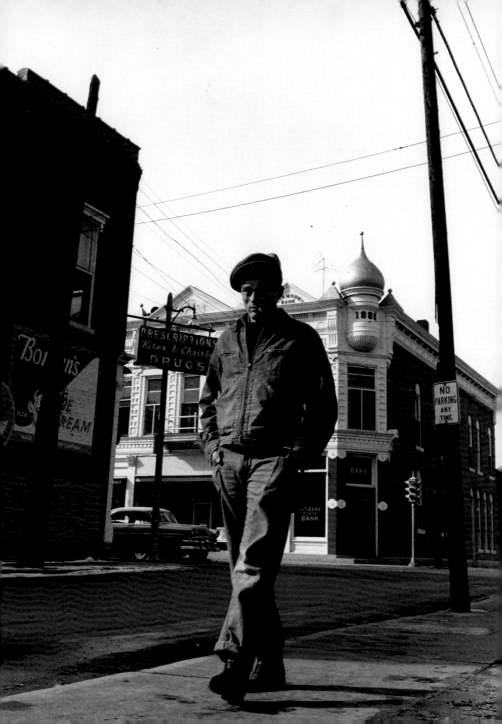

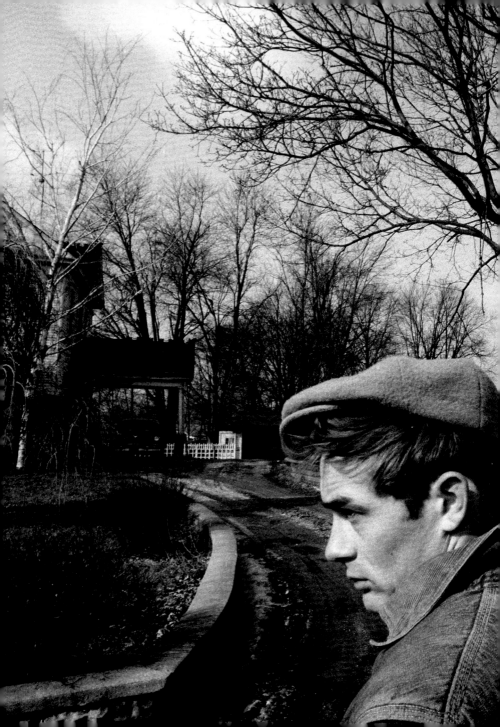

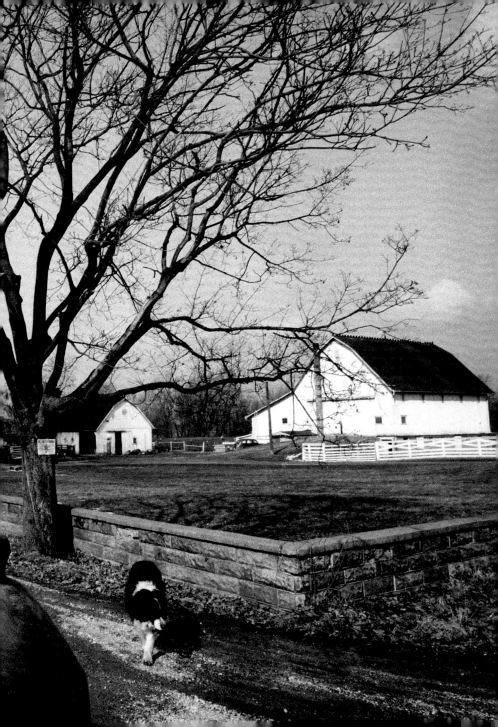

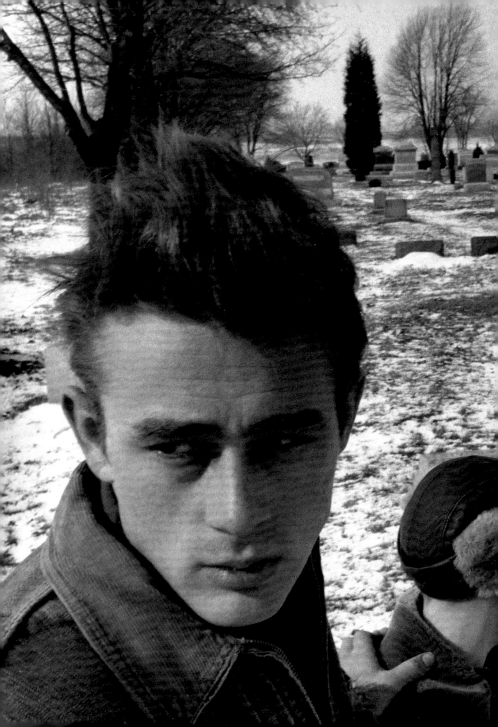

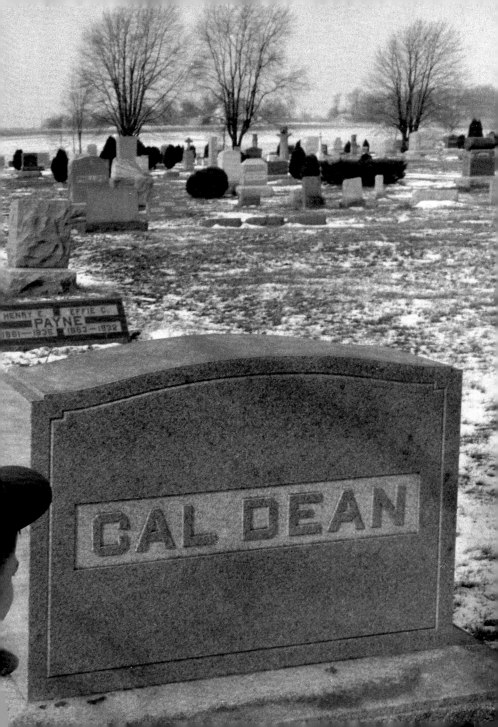

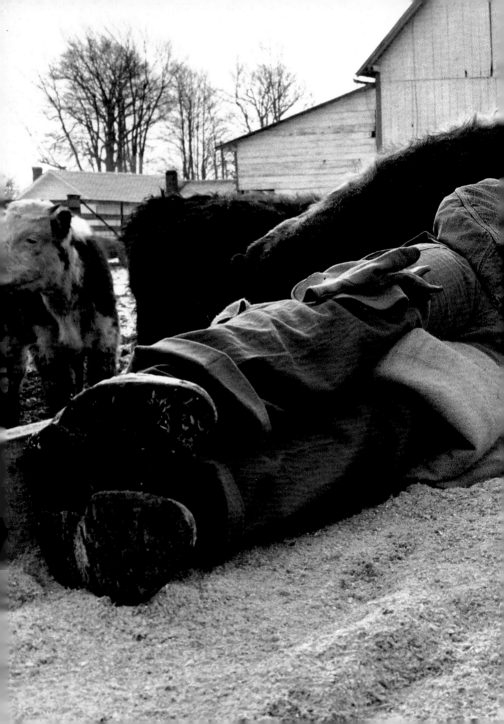

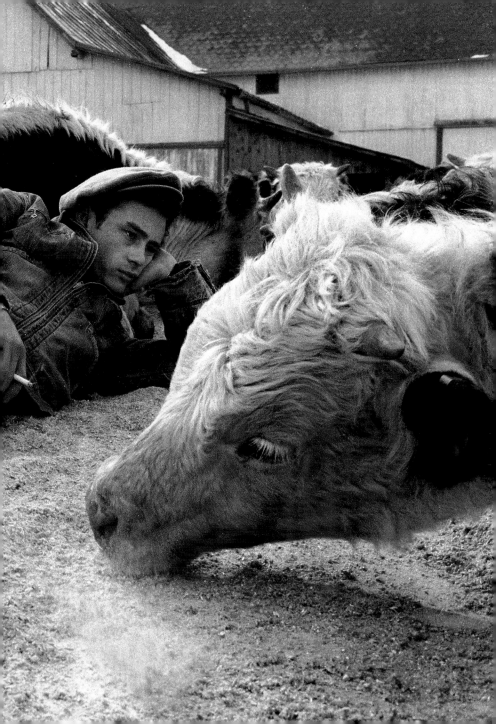

James Dean as existential cowboy on a frozen puddle at the Winslow farm.

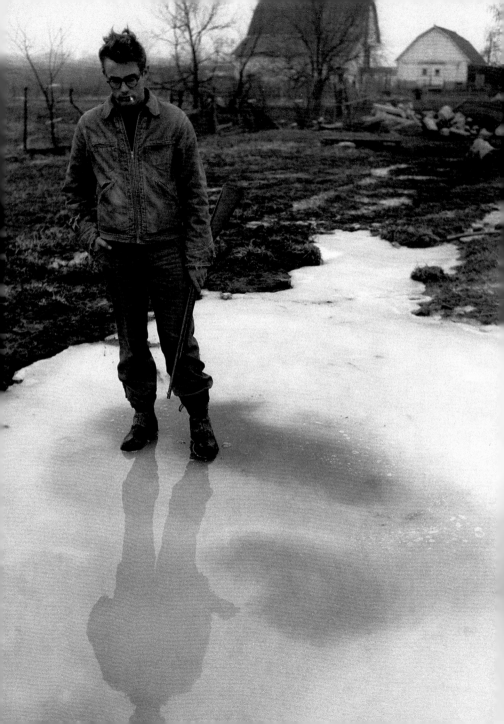

Page 69

This picture by Dennis Stock, "Ferrotype with Sow," was to become a classic.

Pages 70/71

James Dean on the staircase of his old school in Fairmount.

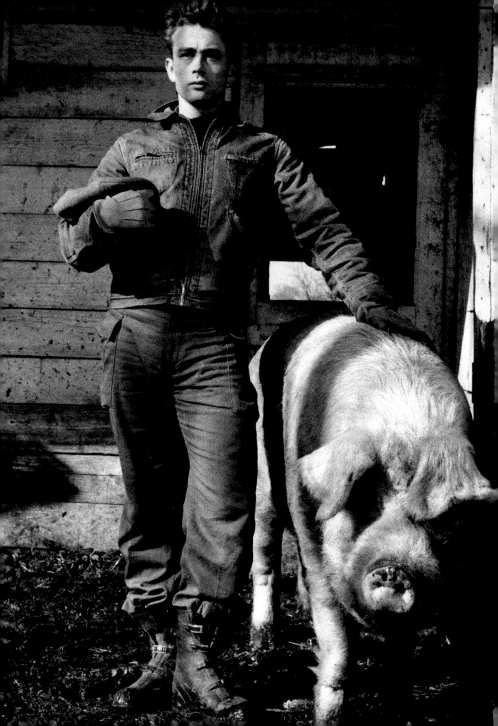

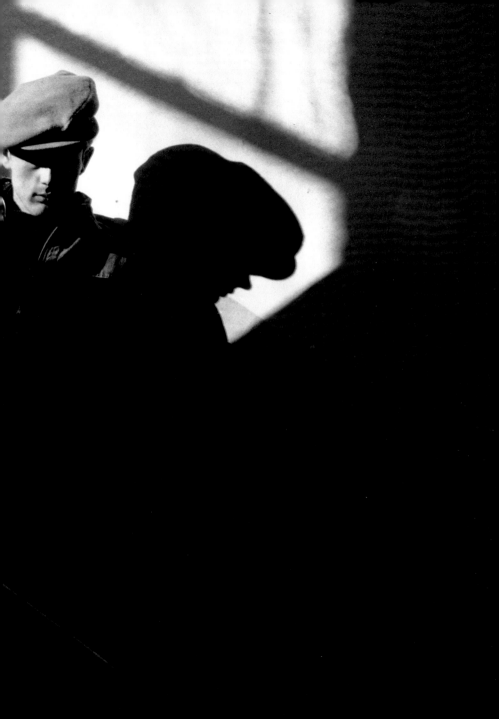

New York

Pages 73–75

Truly characteristic and an integral part of the Dean iconography are the photos that show James Dean walking alone through the cavernous streets of Manhattan—here Times Square in the rain. The trademark of these pictures is the cigarette dangling from the corner of his mouth. Photos by Dennis Stock, 1955.

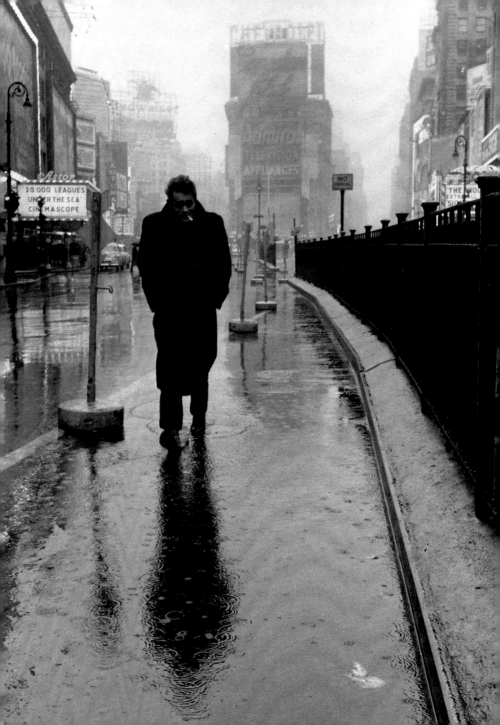

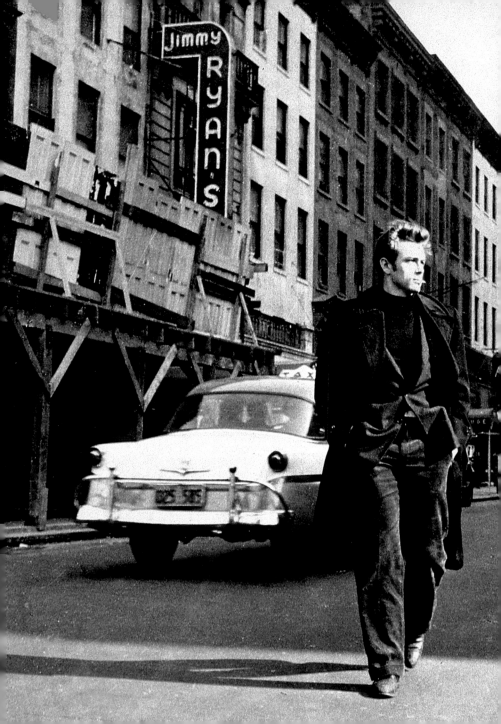

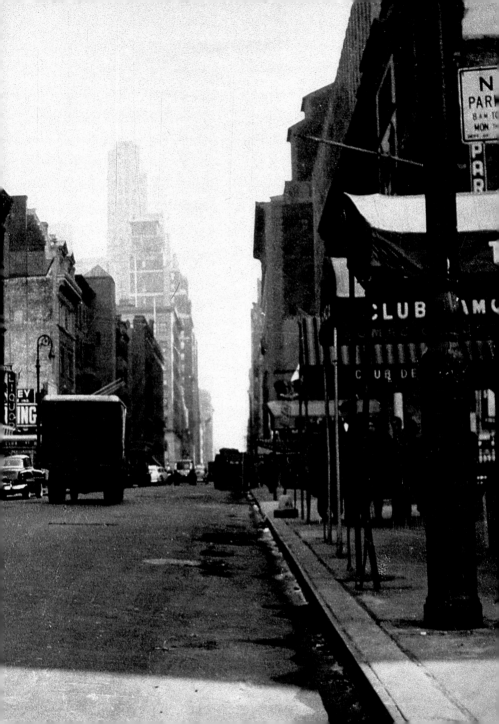

Photographer Roy Schatt met Dean in February 1954 while Dean was appearing as Bachir in the play *The Immoralist* with Louis Jourdan and Geraldine Page. During their ensuing friendship Roy Schatt gave James Dean instruction in photography. The picture opposite is one of the most famous photographs that Roy Schatt took of James Dean. It shows him walking down a New York street like a lonely cowboy on his way to the saloon.

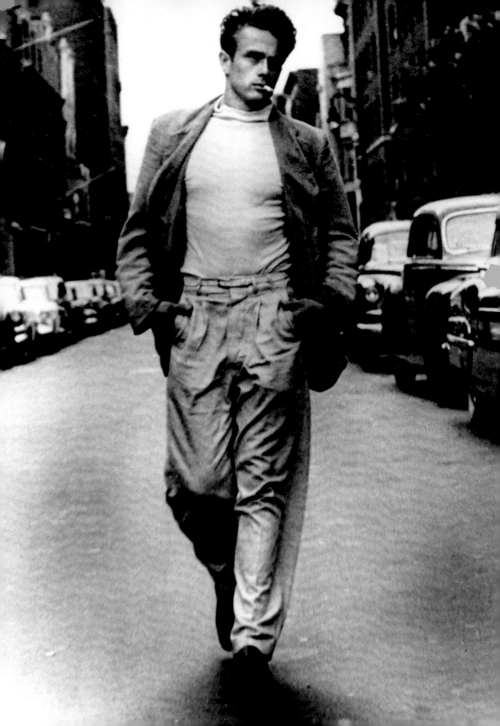

James Dean portrait by Roy Schatt.

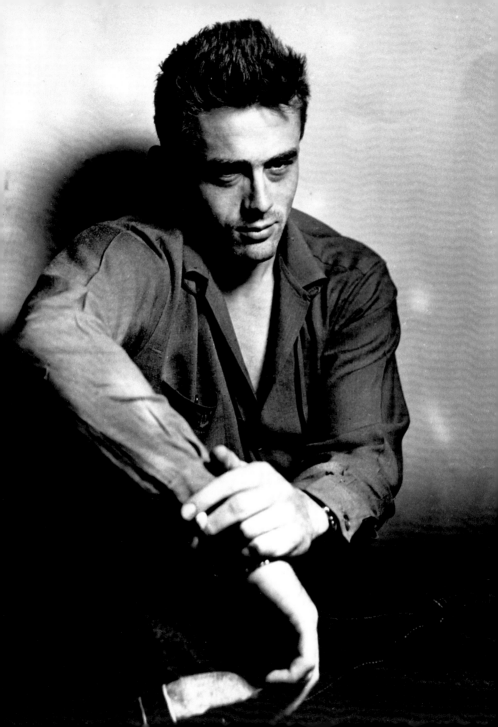

Rebel Without a Cause

Filmed from March to May 1955 by director Nicholas Ray

James Dean, as Jim Stark, joins a gang of juvenile delinquents in his new school whose common goal is rebellion against the lack of understanding shown by their parents and society. When Jim falls in love with Judy, played by Natalie Wood, he provokes the enmity of the gang leader Buzz, Judy's boyfriend. As a test of courage, Buzz and Jim climb into two stolen cars and race to the edge of a cliff, with the first to bail out being "chicken." Buzz can't get the door open and is killed.

James Dean's trademarks in the teenage drama *Rebel Without a Cause* were blue jeans and a red windbreaker. Film still, 1955.

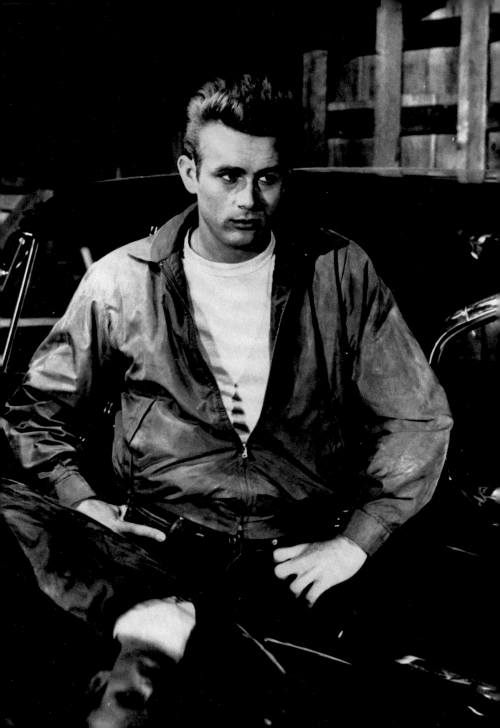

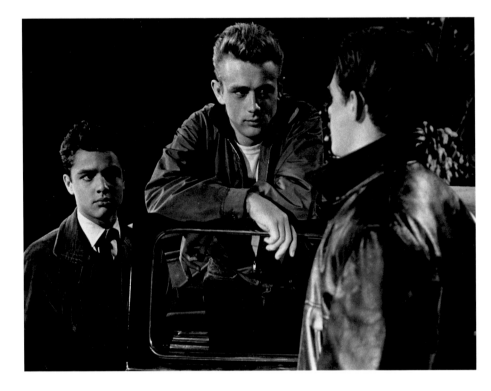

James Dean as Jim Stark in *Rebel Without a Cause*.

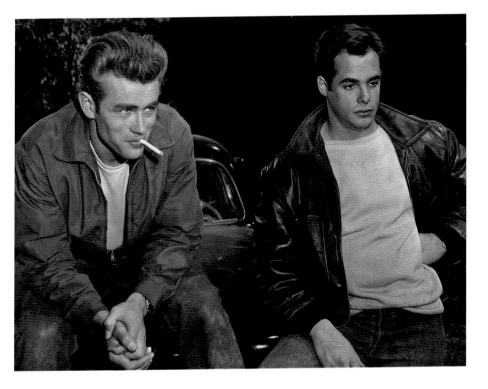

James Dean with Buzz (Corey Allen), the gang leader, during a breather before the race. Film still from *Rebel Without a Cause*.

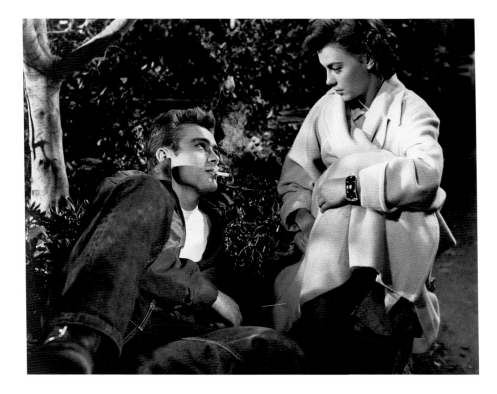

Pages 84/85

Rendezvous with Judy (Natalie Wood), Buzz's girlfriend, in *Rebel Without a Cause*.

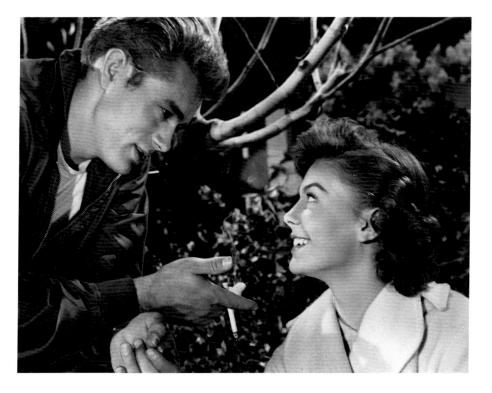

Pages 86/87

A high point of *Rebel Without a Cause*, the knife fight between Jim (James Dean) and Buzz (Corey Allen).

Pages 88–91

Jim with his gang in front of the Police Station (second from left: Dennis Hopper) and during the ensuing confrontation with his father (Jim Backus). Stills from *Rebel Without a Cause*.

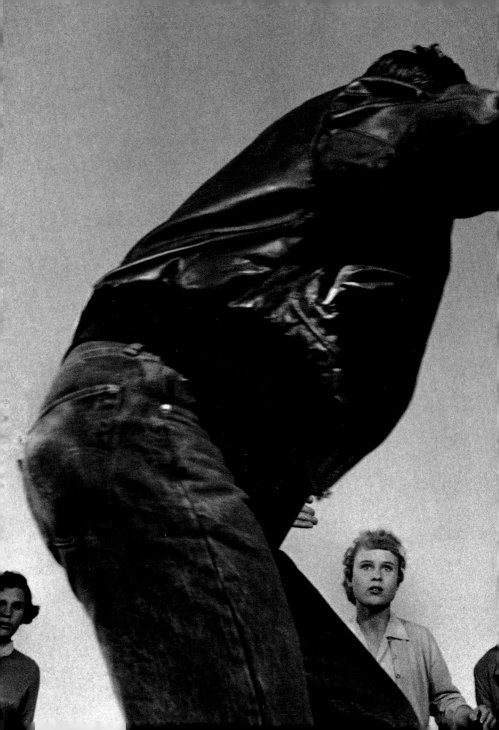

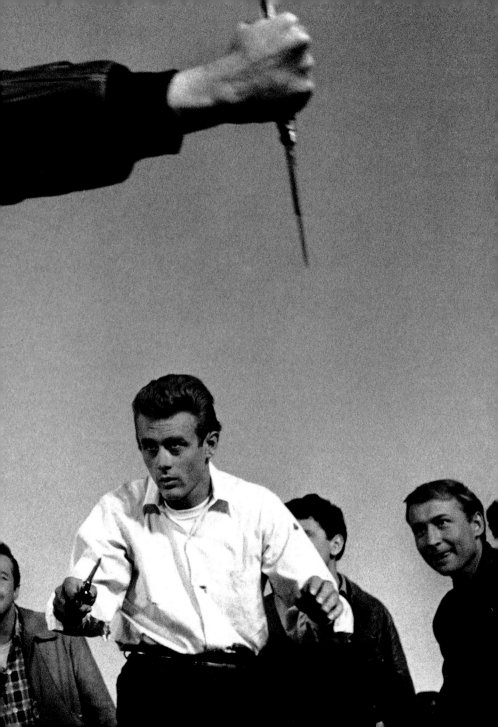

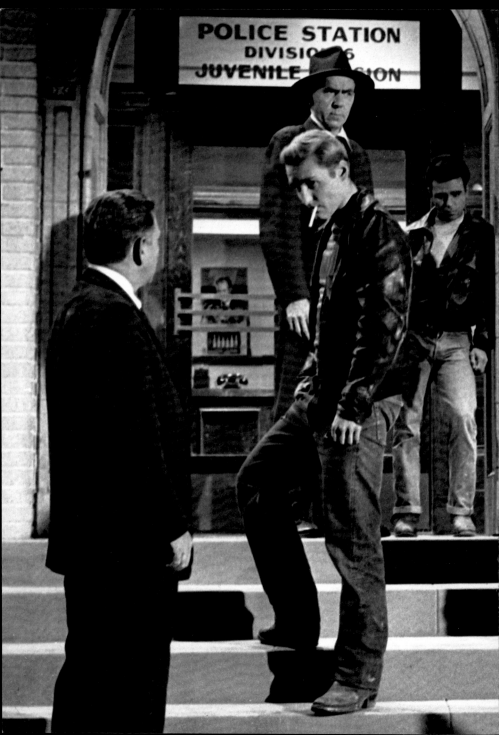

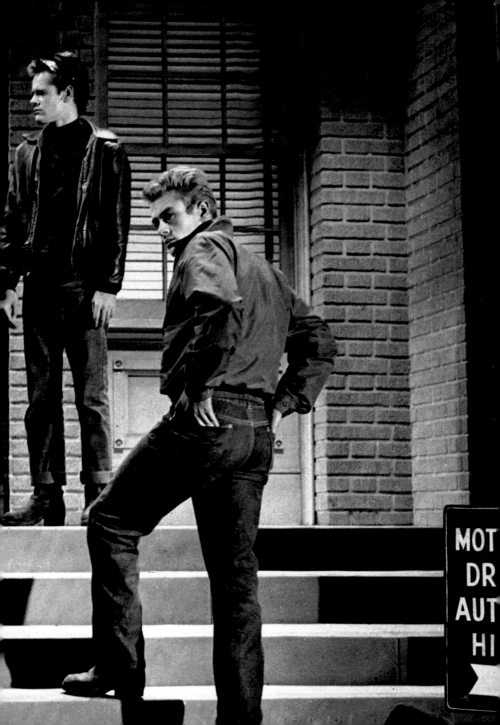

MOT
DR
AUT
HI

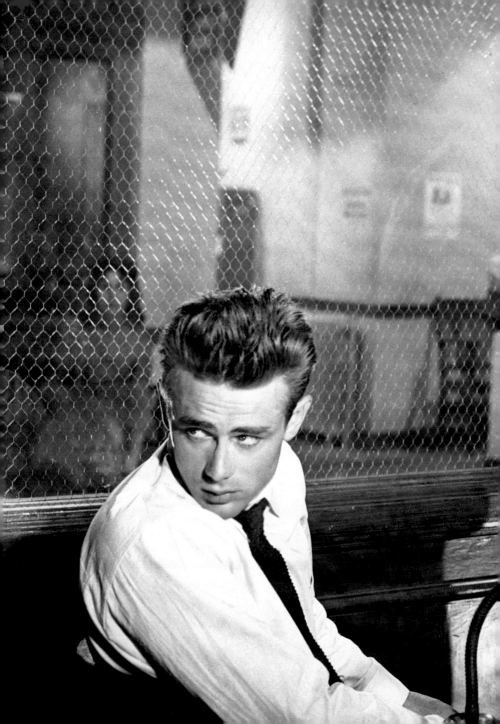

Film still from *Rebel Without a Cause*.

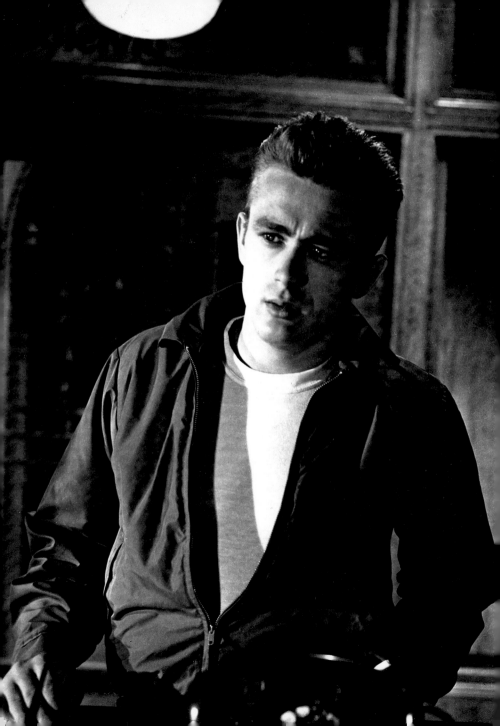

Film still from *Rebel Without a Cause*.

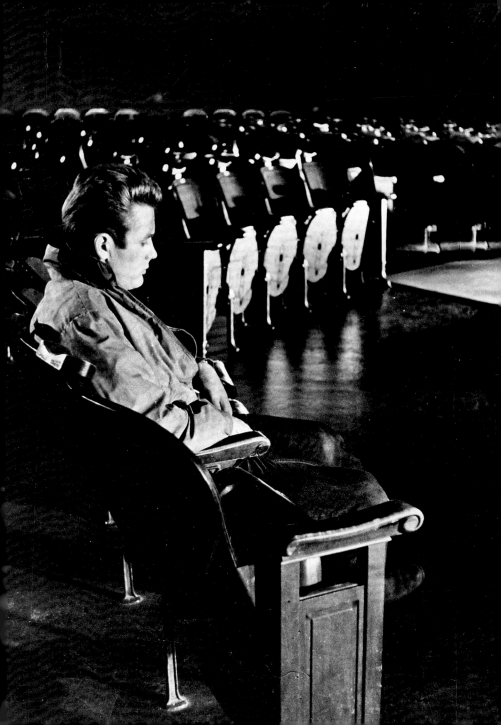

Giant

Filmed from May to September 1955 by director George Stevens.

*Alongside Rock Hudson as Bick Benedict and Elizabeth Taylor as his wife
Leslie, James Dean plays the hired hand Jett Rink, who inherits a small
parcel of the Benedict Reata Ranch from Bick's deceased sister Luz and who
decides to keep the land despite Bick's attempt to buy him out.*

*One day Jett Rink strikes oil and becomes a multimillionaire. The film
then jumps thirty years in time—the sympathetic, sarcastically direct Jett
Rink has become a brutal, unscrupulous parvenu who is addicted to the
bottle.*

Pages 97–99

Jett Rink on small inherited parcel of land that he defiantly named "Little
Reata." Film still from *Giant*, 1955.

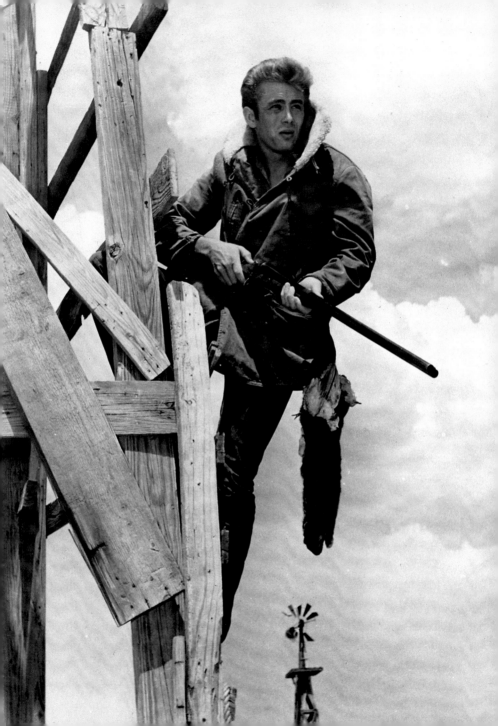

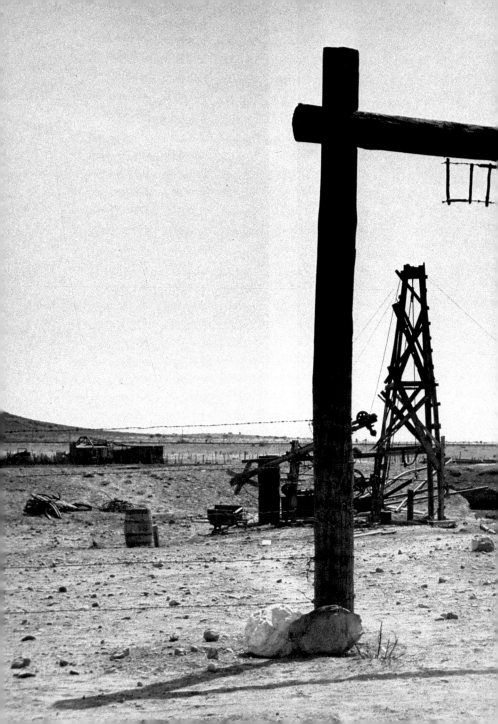

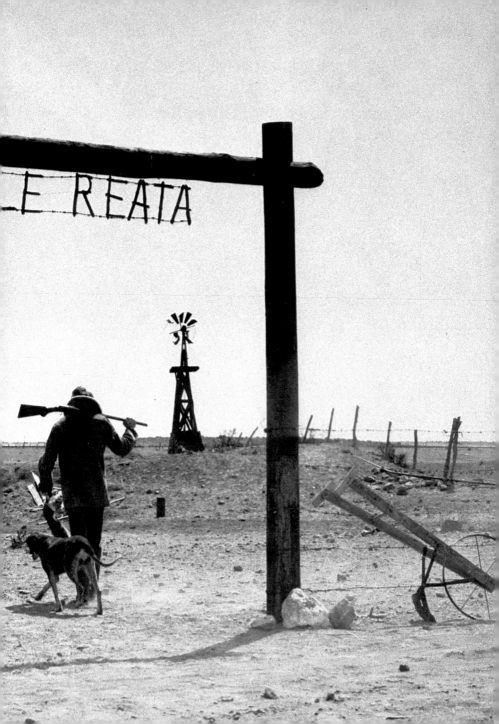

Page 101

In *Giant* Jett Rink, the outsider, challenges the establishment. He plays the surly ranch hand who rises from a no-count to an oil baron—it is no accident that his initials, J.R., are later used for one of TV's major villains.

Pages 102/103

James Dean alias Jett Rink with Elizabeth Taylor playing the role of Leslie, the wife of Jett's rival Bick Benedict (Rock Hudson). Film still from *Giant*.

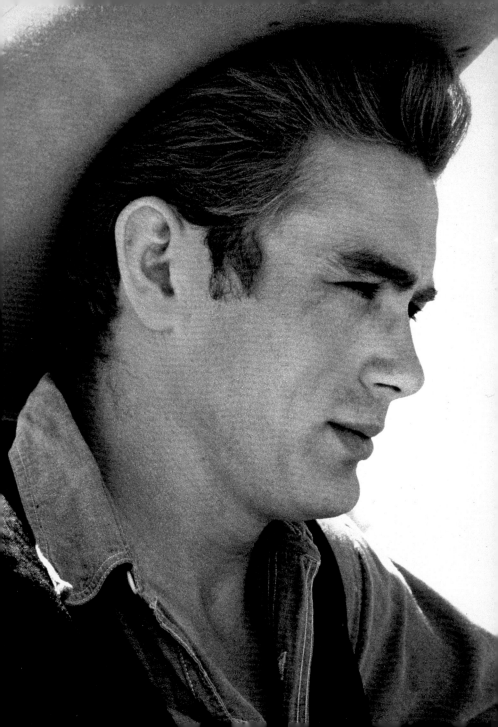

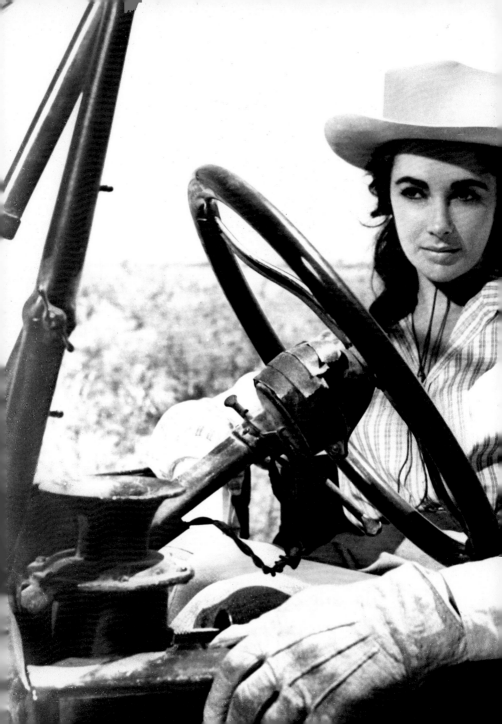

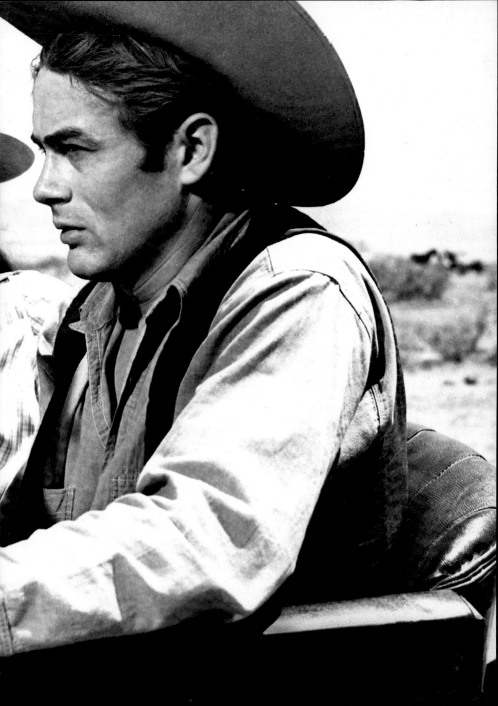

Page 105

Director George Stevens first portrays Jett Rink as a victim of society, as in this stylized crucifixion scene with Elizabeth Taylor, probably the most famous shot from the film.

Pages 106/107

Leslie (Liz Taylor) enjoying Jett Rink's simple hospitality in his small cabin. Film still from *Giant*.

Pages 108/109

This scene in front of Benedict's palatial ranch house underscores Jett Rink's transformation from victim to culprit. A still from *Giant*.

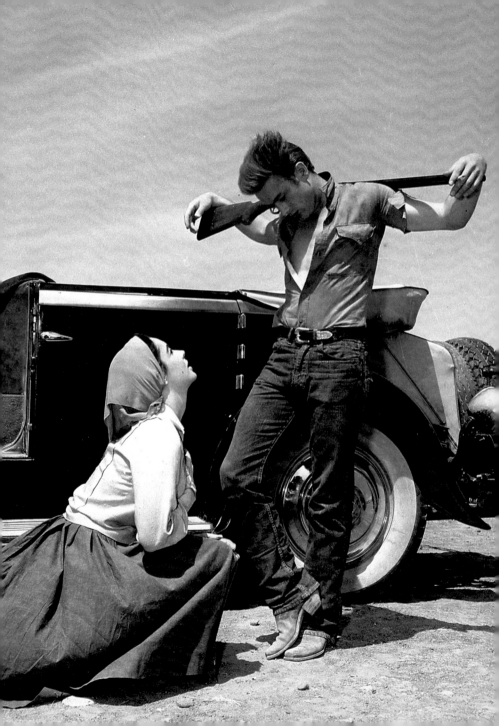

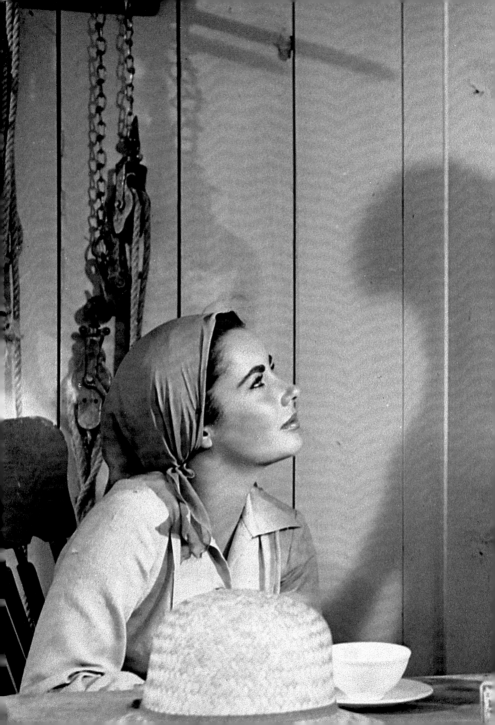

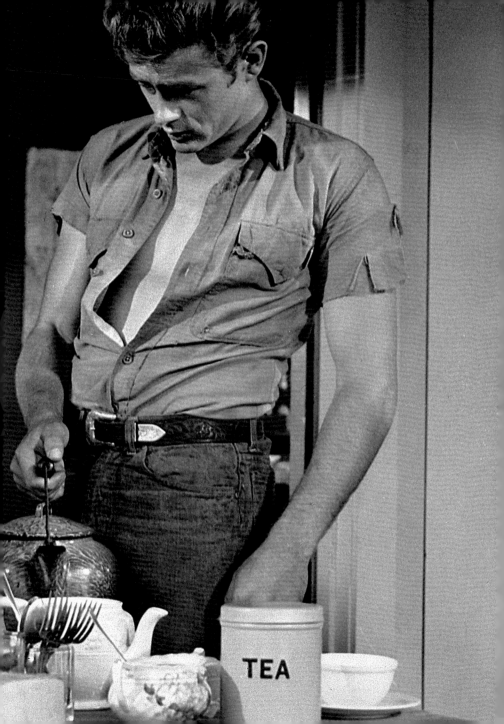

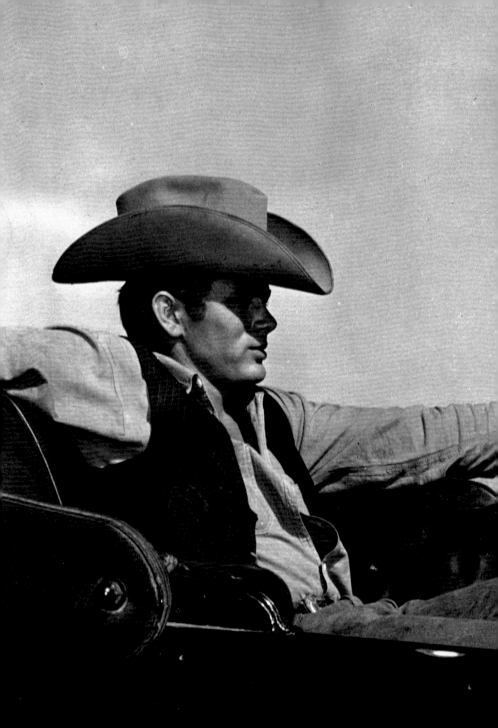

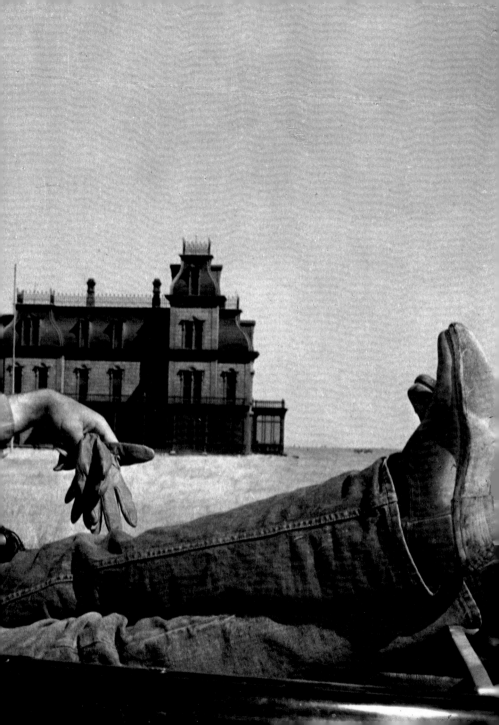

Jett Rink is obsessed with finding oil on his parcel of land. When he finally strikes it rich, his American dream is fulfilled. Film still from *Giant*.

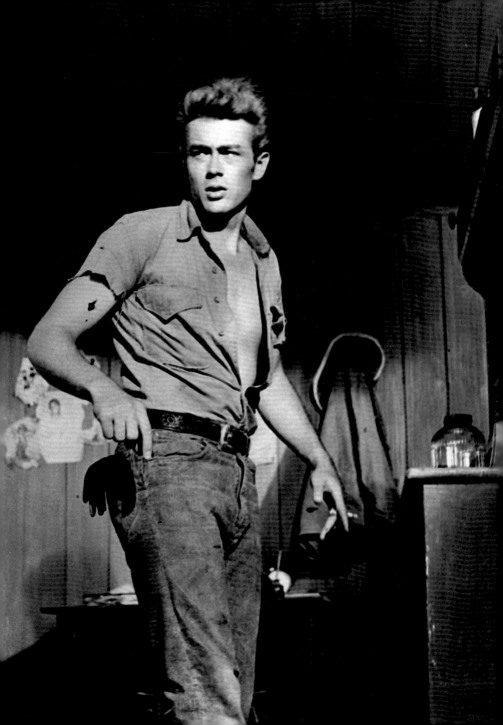

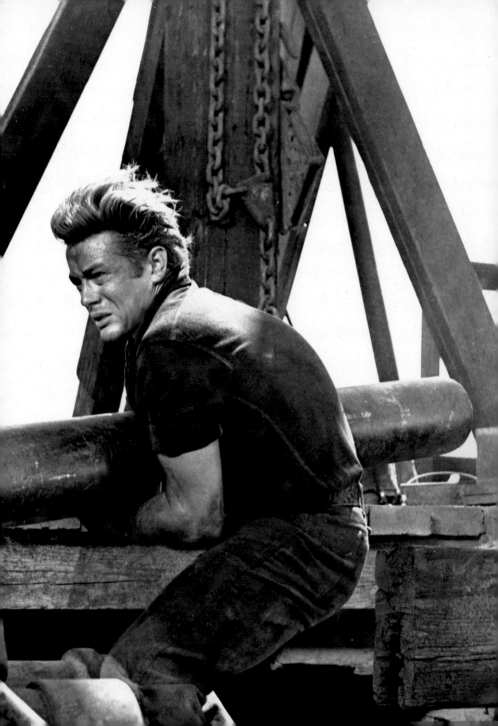

Pages 117–121

The shooting for *Giant* in Marfa, Texas, was documented by the photographer Sanford Roth, among others. This picture of James Dean twirling a six-shooter and the following photos of James Dean and Elizabeth Taylor were both taken by Roth.

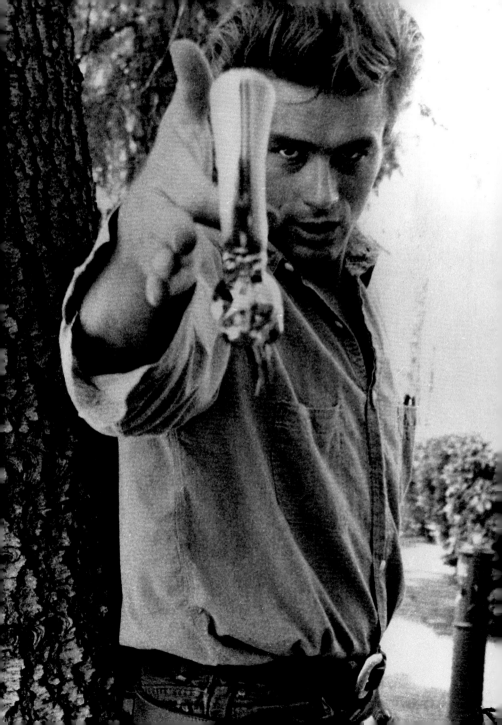

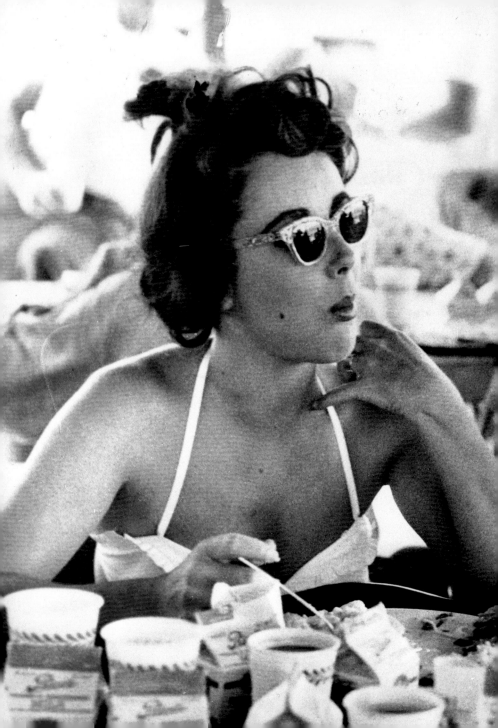

"It's impossible not to be captivated by James Dean," seems to be the motto for this photograph by Sanford Roth, where James Dean has demonstrated his lassoing skills on Elizabeth Taylor.

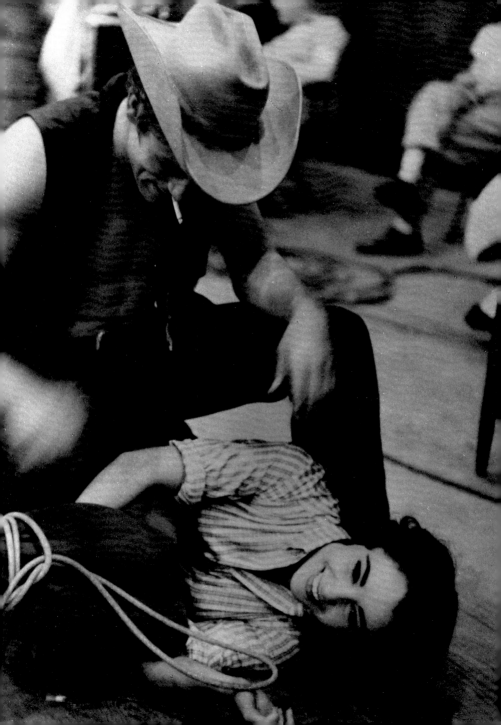

Epilogue

In addition to acting, James Dean was obsessed by car racing and idolized drivers such as Tazio Nuvolari and Alberto Ascari. On March 1, 1955, he bought a 1500 cc Porsche Speedster in which he won local races in Pacific Palisades and Pasadena. His racing passion was so well known and feared that his film contracts expressly forbade him to race during shooting. On September 21, 1955, the last day of work on Giant, *Dean traded in his Porsche Speedster for a Porsche Spyder, which he gave the final check to at the garage at 8 a.m. on September 30, together with his mechanic Rolf Wütherich. In the afternoon Dean and Wütherich set off for Salinas to take part in the races. Photographer Sanford Roth accompanied them in a second car and was an eyewitness of the fatal accident that took place at 5:45 p.m. at the junction of Highway 466 and 41 near Cholame. James Dean was instantly killed, Rolf Wütherich survived.*

Page 123

James Dean at a car race.

Pages 124/125

James Dean in his Porsche.

Pages 126/127

James Dean with Rolf Wütherich during his last drive. Photo by Sanford Roth.

Pages 128/129

The wrecked Porsche at the scene of the accident. Photo by Sanford Roth.

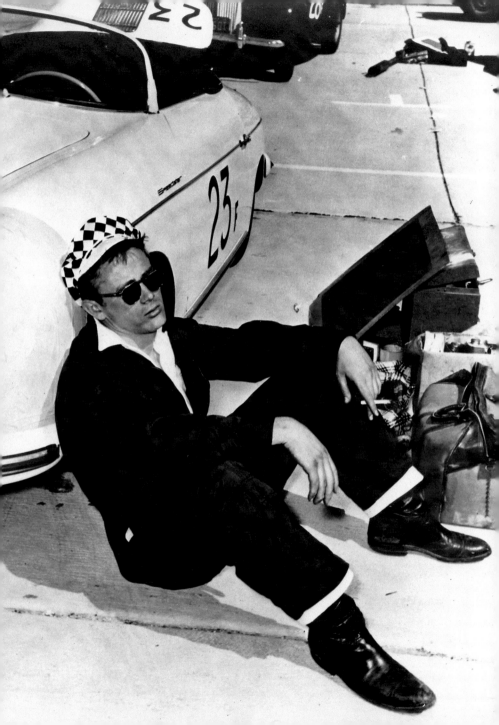

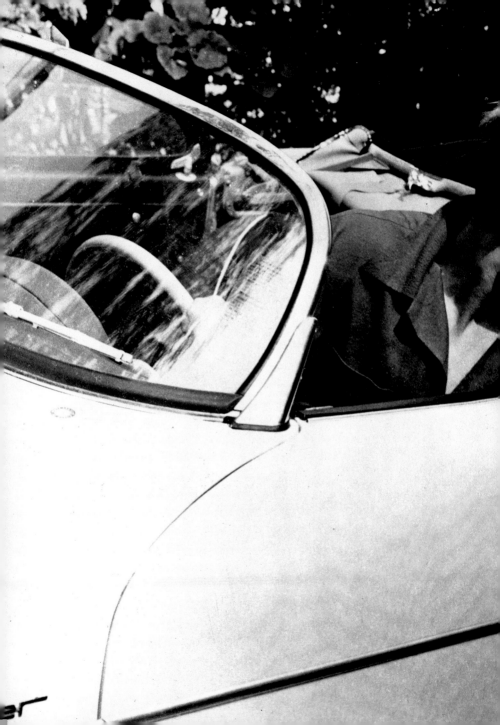

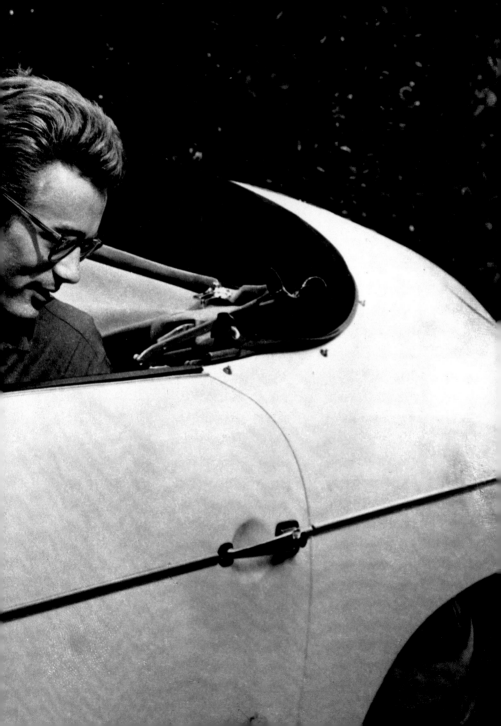

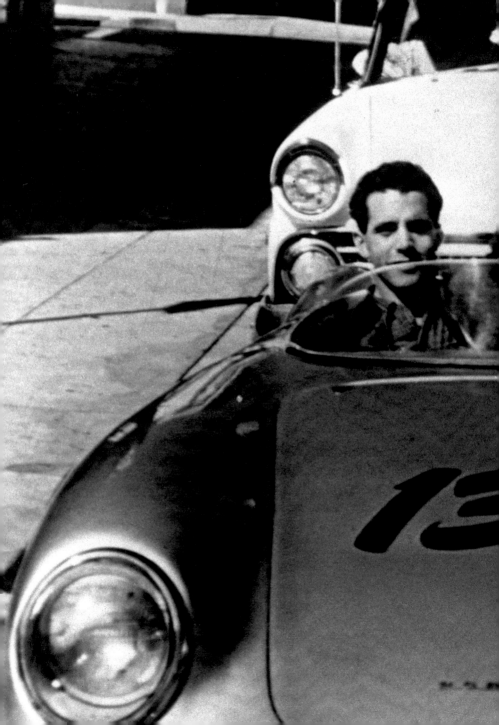

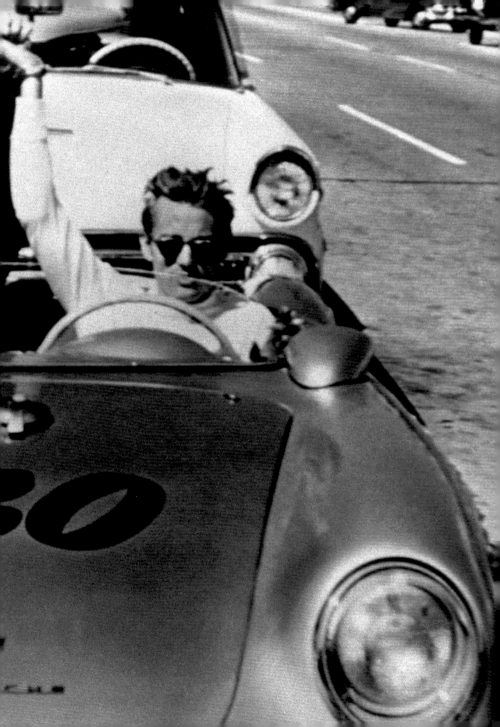

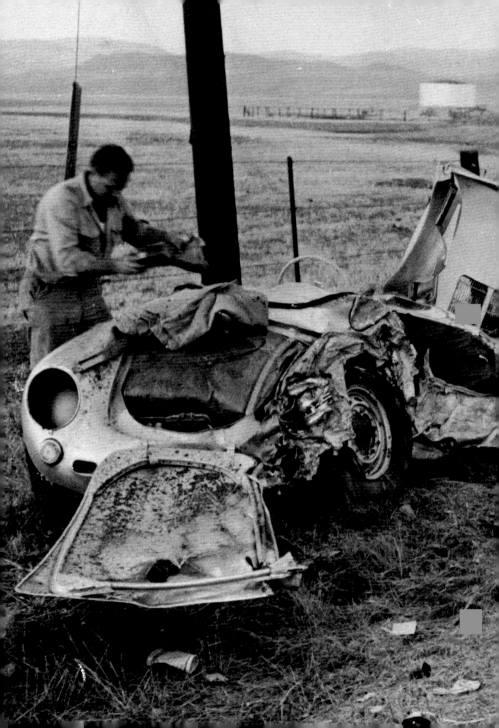

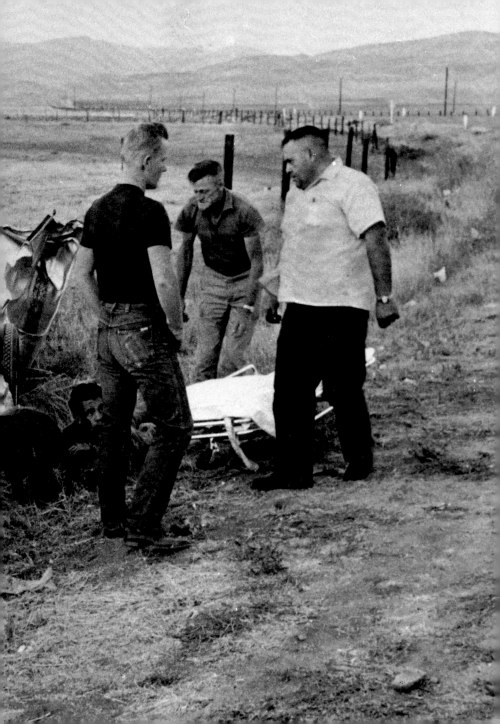

After the fatal accident, police officer Ernie Tripke reported: "The driver appeared to be dead. His head was uninjured but his chest was pierced by the steering column as if by the horns of a steer. I had never heard of James Dean, the movie star. After much thought and pondering in my mind I felt it was Jimmy Dean who sang cowboy and western songs . . . I kept getting radio calls asking about him. And when I got to the hospital later in the evening every phone in the place was ringing, and all the lights were flashing and we had news media calling from all over. That's when I heard for the first time that James Dean was a movie star."

Biographical Sketch

1931 February 8: James Byron Dean is born to Winton and Mildred Dean of Marion, Indiana. He is named James after James Emmick, the attending physician, and Byron—so it is said—after the poet Lord Byron.

1940 April 14: Mildred Dean dies of breast cancer in Los Angeles.

1947 Autumn: James Dean, a junior at Fairmount, Indiana, High School, plays the role of Otis Skinner in *Our Hearts Were Young and Gay*.

1948 October 29: Plays the part of Frankenstein at Fairmount High's Halloween Gala, *Goon With the Wind*.

1949 February 8: Registers for the draft on his eighteenth birthday.
April 7: Plays the part of Grandfather Vanderhof in the senior class production, *You Can't Take It with You*.
April 9: At the state speech meet in Peru, Indiana, James Dean wins first-place honors with his reading of "The Madman" from Charles Dickens's *The Pickwick Papers*.
April 29–30: Accompanied by his drama teacher, Adeline Nall, he represents Indiana at the National Forensic League contest in Longmont, Colorado, where he is eliminated in the semifinal round.
June 14: After graduation and before leaving for California, James Dean is honored at a farewell party which makes the headline of *The Fairmount News*.
Autumn: Enrolls at Santa Monica City College due to high out-of-state tuition fees at UCLA

1950 May: Appears in melodrama, *She Was Only a Farmer's Daughter*, at SMCC's May Day festivities.
September: Enrolls at UCLA.
November 29: Performs the role of Malcolm in UCLA's *Macbeth* production, where his demeanor antagonizes some of the cast.
December 13: First paid job as an actor, receiving $30 for a Pepsi-Cola commercial.

1951　January: Drops out of UCLA. Attends James Whitmore's acting workshop, which uses the Stanislavski method.

March: Plays the apostle John in his first television show, "Hill Number One," an episode of *Father Peyton's TV Theater*.

July: His first screen appearance with a bit role in *Fixed Bayonets*, where he appears at the end of the film with the line, "It's a rear guard coming back." Later in the summer he also has a small part in the Dean Martin and Jerry Lewis film, *Sailor Beware*. In the movie *Has Anybody Seen My Gal?* he tells the drugstore soda jerk, Charles Coburn, "Hey Gramps! I'll have a choc malt, heavy on the choc, plenty of milk four spoons of malt, two scoops of vanilla ice cream, one mixed and one floating!" After fluffing three consecutive takes, he commented: "Only an ice cream freak could get that load of garbage right first time."

September: Moves to New York on Whitmore's advice. Shortly thereafter, is taken on as a client by Jane "Mom" Deacy of the Louis Schurr Agency, who gets him a job as stunt tester for the TV show *Beat the Clock*.

1952　February 20: Appears in live CBS TV drama, *The Web*.

Summer: Plays a Civil War soldier in *Summer Studio One's* "Abraham Lincoln."

October: Receives his first Broadway role in *See the Jaguar*, where he plays a boy sequestered in an ice house by his demented mother.

November 12: Auditions with Christine White for the Actors Studio with a self-written scene. Both are chosen from among 150 applicants.

December: *See the Jaguar* at Cort Theater, New York, flops during the first week. James Dean is strongly complimented by Walter Kerr in the *New York Herald Tribune*.

1953　Numerous television appearances throughout the year. Begins a relationship with Barbara Glenn and moves into his own apartment at 19 West 68th Street.

December: Receives the role of Bachir, the blackmailing Arab houseboy, in *The Immoralist*, with Louis Jourdan and Geraldine Page. During a break in rehearsals he drives to Indiana on his Triumph 500 motorcycle.

1954　February: After the Broadway opening of *The Immoralist*, Dean gives two weeks' notice that he is quitting. For this performance he earns the Daniel Blum Theatre World Award later in the year as one of the most promising new Broadway personalities.

Learns photography from Roy Schatt during the winter

March: Elia Kazan, who had seen *The Immoralist*, selects James Dean for a

role in *East of Eden*.

April 7: Dean signs a Warner Brothers' contract for the role of Cal Trask in *East of Eden*. He receives a $700 advance, which goes to buying an MG TA sports car.

May 27: Shooting for *Eden* begins in Mendocino, California, and continues to mid-August.

Summer: Love affair with Italian actress Pier Angeli.

September 5: Back in New York for the *Philco TV Playhouse* (NBC) episode "Run Like a Thief."

November 24: Pier Angeli and Vic Damone are married in Westwood. Jimmy watches on his motorcycle across the street.

December: Role as killer in "The Dark, Dark Hours" for the *General Electric Theater* (CBS) who holds the country doctor, Ronald Reagan, hostage.

1955 January 4: Warner Brothers announces that James Dean will play the role of Jim Stark in *Rebel Without a Cause*.

February: Return to Fairmount with Magnum photographer Dennis Stock.

March 1: Dean buys a 1500 cc Porsche Speedster and wins the races in Pacific Palisades and Pasadena.

March 7: Dennis Stock's photo essay "Moody New Star" appears in *Life* magazine.

March 9: World premier of *East of Eden* in New York's Astor Theater as a benefit for the Actors Studio, with Marilyn Monroe as usherette. James Dean remains in Hollywood.

March 14: Interviewed on *Lever Brothers Lux Video Theatre* (NBC).

March 28: Shooting begins for *Rebel Without a Cause*.

April 2: Dean's contract with Warner Brothers is extended once again and he is given the role of Jett Rink in the film version of Edna Ferber's *Giant*.

May 21: Shooting for *Giant* begins.

May 25: Filming for *Rebel Without a Cause* is completed.

May 28 & 29: Dean races his Porsche at Santa Barbara before joining the film crew for *Giant* on June 3.

September 21: Trades in his Porsche Speedster for a Porsche Spyder 550 and has the start number "130" and "Little Bastard" painted on it.

September 22: Finishes work on *Giant* with the "Last Supper" scene.

September 30, 8 a.m.: James Dean and his mechanic Rolf Wütherich give the Porsche its final checkup at Competition Motors.

5:45 p.m.: At the junction of Highway 466 and 41 near Cholame, Dean's Porsche collides with a Ford sedan driven by Donald Turnupseed.

Wütherich is thrown clear of the car and survives. James Dean is killed instantly.

October 26: *Rebel Without a Cause* premiers in New York.

November 10: *Giant* opens in New York.

Bibliography

Bast, William. *James Dean: a Biography*. New York: Ballantine Books, 1956.

Dalton, David and Ron Cayen. *James Dean: American Icon*. New York: St. Martin's Press, 1984.

Herndon, Venable. *James Dean: A Short Life*. Garden City, New York: Doubleday, 1974.

Holley, Val. *James Dean: Tribute to a Rebel*. London: Omnibus, 1991.

Howlett, John. *James Dean: A Biography*. London: Plexus, 1975.

Königstein, Horst. *James Dean*. Hamburg, 1977.

Martinetti, Ronald. *The James Dean Story*. New York: Pinnacle Books, 1979.

Roth, Sanford and Beulah: *James Dean. Ein Portrait*. Munich, 1984.

Schatt, Roy. *James Dean, A Portrait*. New York: Delilah Books, 1982.

Stock, Dennis. *James Dean Revisited*. New York: Viking Press, 1978.

Wolf, Kim. *Das kurze, wilde Leben des James Dean. Idol und Legende*. Bergisch Gladbach, 1979.